HIDDEN
HISTORY
of
NORTHERN
VIRGINIA

CHARLES A. MILLS

THE
History
PRESS

Published by The History Press
Charleston, SC 29403
www.historypress.net

First published 2010

Manufactured in the United States

ISBN 978.1.59629.831.6

Library of Congress Cataloging-in-Publication Data

Mills, Charles A.
Hidden history of Northern Virginia / Charles A. Mills.
p. cm.
Includes bibliographical references.
ISBN 978-1-59629-831-6
1. Virginia, Northern--History, Local. I. Title.
F232.N867M55 2010
975.5'2--dc22
2009053678

For Jack

CONTENTS

CONTENTS

PREFACE

Northern Virginia is Washington, D.C.'s front porch, and while the history of the entire nation has been made in Washington, Northern Virginia has a rich regional history flowing from its connection to the capital. For example, there would be no Washington, D.C., if General George Washington had not lived in nearby Mount Vernon, Virginia.

Included here are the often-overlooked stories of Northern Virginia from colonial to modern times—stories such as the Rebel blockade of the Potomac River, the imprisonment of German POWs at super-secret Fort Hunt during World War II and the building of the Pentagon on the same site and in the same configuration as Civil War–era Fort Runyon. And then there are the people—Alexandria hometown boy Robert E. Lee, Annandale's "bunny man" who inspired a wild and scary urban legend, slaves in Alexandria's notorious slave pens, suffragists dragged from in front of the White House and imprisoned in the Occoquan Workhouse and many other folks who have left their imprints on the region and the nation.

Henry Ford once said, "History is more or less bunk. It's tradition. We want to live in the present, and the only history that is worth a tinker's damn is the history we make today." What I have learned in collecting the stories for this book is that Mr. Ford's view of history is more or less bunk. Our lives are connected to everyone who has ever lived in Northern Virginia and, more importantly, to everyone who will ever live here in the future. The history of Northern Virginia is the story of people living day in and day out, interacting with one another for good or ill. What we do every day is

important in this unending chain of cause and effect. There are no ordinary moments. If you want a better world, be a better person.

Many fine historians and history enthusiasts have shared their insights and knowledge with me. I want to especially thank my son, Andrew Llewellyn Mills, a consummate storyteller with a true passion for history; Doug Harvey; Dr. Pamela Cressey with Alexandria Archaeology; Jim Bartlinksi with the Carlyle House; Marion Meany; Mary Lipsey; Audrey Davis with the Alexandria Black History Museum; Carlton Funn Sr.; Don Hakenson; Brad Bradshaw; Professor Jane Turner Censer with George Mason University; Francis Gary Powers Jr. with the Cold War Museum; Walt Guenther; Lynne Garvey-Hodge; Andrea Loewenwarter with Historic Blenheim; Carolyn Gamble; Charlie Davis; and Wellington Watts.

In the Beginning

The history of Northern Virginia began long before the arrival of European settlers. The earliest known inhabitants arrived in the area some thirteen thousand years ago, as recently highlighted by the 2007 discovery of a so-called Clovis point in the city of Alexandria. Clovis points were manufactured and used by bands of hunters roaming the grasslands and forests covering the area as the glaciers from the last ice age began to recede. To date, about one thousand Clovis points have been found in Virginia, including the one in Alexandria and several in Fairfax and Loudoun Counties. Native Americans in this area left no written records, so our story begins with the Europeans, the first record-keepers. Early European colonists were a hardy lot who had to contend with unfriendly natives, hunger and disease.

Spanish Explorers on the Potomac

Most people think that Captain John Smith was the first European to explore in Northern Virginia, but there is evidence that Spanish explorers beat Smith by several decades.

An attempt at colonization was made in 1570, when Governor Pedro Menéndez of Florida authorized an expedition. At the time, it was believed that the Chesapeake Bay was the long-sought passage to China. Jesuit

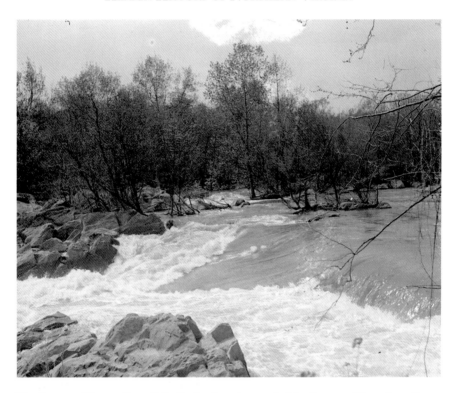

The Potomac River at Great Falls. Native Americans called the Potomac River above Great Falls *Cohongarooton,* "river of geese." *Courtesy of the Library of Congress.*

missionaries convinced the governor to send an unarmed expedition to the area as a forerunner to future colonization. On September 10, 1570, eight Jesuits headed by Father Segura, vice provincial of the Jesuits, settled near a place Native Americans called Axacan.

The Jesuits were convinced that they could gain the trust of the natives and convert thousands to Christianity for one simple reason: they were accompanied by a prince of that country who had converted to Christianity in Spain itself. An earlier Spanish expedition had sailed into the Chesapeake Bay in 1560 and encountered Native Americans. A young son of one of the Powhatan chiefs agreed to accompany the Spaniards when they sailed away. The boy was baptized and renamed Don Luis in honor of his sponsor, Don Luis de Velasco. He was educated in Mexico and Spain and returned to his own country with the Jesuits in 1570.

Shortly after returning, Don Luis rejected his Spanish name, renounced Christianity and returned to his people. In February, he led a group of armed warriors and killed the eight Jesuit missionaries, sparing only a young

boy named Alonzo, whom the Jesuits had brought as an altar boy. Alonzo eventually made his way to the village of a rival tribe and was finally rescued by a Spanish ship bringing supplies to the Jesuits.

When Governor Menéndez learned of the massacre, he sailed for Axacan. In early 1572, the Spanish returned to Virginia, capturing and hanging a number of Powhatan men accused of participating in the massacre. The backsliding former convert Don Luis was never located. Some historians believe that he was later to give the English settlers at Jamestown trouble, speculating that Don Luis was in fact Opechancanough, a Powhatan chief who organized a ferocious massacre of English settlers in 1622. The name Opechancanough means "he whose soul is white" in the language used by the Powhatan people.

Historians are divided in pinpointing the exact location of Axacan. Was it a local name or that of the country? The nearest surviving Indian word that suggests the name is *Occoquan*, the river that forms the boundary between Fairfax and Prince William Counties. One historical school places the unfolding drama in a village located on the Occoquan River in Northern Virginia.

The last record of Spanish visits to the Chesapeake is contained in a report by Pedro Menéndez sent to King Philip II of Spain. In this report, he states that for some years "bison skins were brought down the river (Potomac) and thence carried along shore in canoes to the French seated at the mouth of the St. Lawrence River." The Indian name for the tribe that carried out this trade was Patawomeck, which translated means "they go and come" (i.e., travel for trade). The river was named for this tribe.

COLONIAL DAYS

The English founded Jamestown in 1607 and over the course of the next one hundred years moved steadily northward, displacing the original Native American inhabitants. At first, the Indians, who did not understand the concept of privately owned land, granted the English permission to live within their territories. The English regarded this as the Indians ceding the lands. The Europeans were pushy—very pushy. In keeping with their time-honored tradition, the Indians left villages for weeks or months on end to go hunting, fishing and gathering, only to find Europeans occupying their villages when they returned. A series of wars broke out that continued through the seventeenth century. Although there were tens of thousands of Indians in

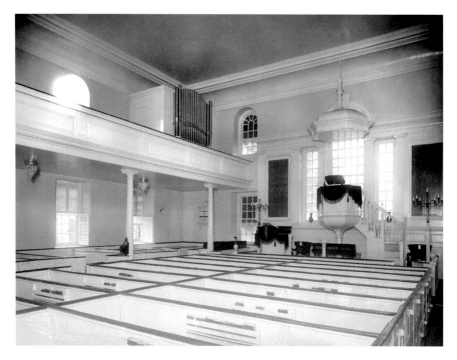

The interior of Christ Church in Alexandria. George Washington often attended this church. *Courtesy of the Library of Congress.*

the area in the seventeenth century, steady European immigration soon tilted the demographic balance in favor of the invaders. Diseases brought by the immigrants essentially finished the Indians, with 90 percent of the native population dying off as a result of epidemics within one hundred years.

Following the Potomac River north, settlers reached Northern Virginia. In 1690, Richard Gibson built a gristmill on Quantico Creek, near today's Dumfries. By 1695, a rude settlement was being built near modern Alexandria. Both Dumfries and Alexandria were established as towns in 1749 by Scottish merchants seeking their fortunes in Virginia. The ensuing decades would see a fierce rivalry between the two ports. For about fifteen years, Dumfries was a thriving port, shipping tobacco from the interior to England. At its height, Dumfries was the second busiest port in colonial America, rivaling New York, Boston and Philadelphia. Erosion and silting ultimately left Dumfries high and dry, while Alexandria carried on significant trade for many years to come.

John Carlyle, of Alexandria, stands out as a kind of "representative man" of the colonial period in Northern Virginia. Carlyle, virtually unknown in national history, was the type of man who always loved his family, tended his business and served his community quietly and effectively. He was born

in 1720 in Scotland. He came to Virginia as the agent of a merchant at the age of twenty-one in hopes of making "a fortune sufficient…to live independent." He achieved success within seven years. Carlyle's extensive business activities included import and export trade to England and the West Indies, retail trade in Alexandria, an iron foundry in the Shenandoah Valley, milling and a blacksmithing operation. Carlyle bought thousands of acres of land and operated three working plantations. In 1749, he became one of the founding fathers of Alexandria. In 1753, he built a grand home in Alexandria, overlooking the Potomac River. Carlyle used slave labor in all of his business ventures and was one of the area's largest slave owners. Slaves toiled on his plantations, sailed his ships and hauled his goods. Slave carpenters and masons were used to build his mansion. If Carlyle had any reservations about slavery, he did not voice them.

John Carlyle's life was repeatedly marred by the type of personal tragedy common to the eighteenth century. Of his eleven children, only two lived to adulthood. His first wife, Sarah, bore seven children, five of whom died in childhood. Sarah died in childbirth. Carlyle's second wife, Sybil, bore four children, only one of whom lived to be fifteen years old. This son was killed while serving in the American Revolution. Bacterial stomach infections, intestinal worms, epidemic diseases, contaminated food and carelessness all contributed to a society in which 40 percent of children failed to reach adulthood. Diphtheria, influenza, measles, pneumonia, scarlet fever and smallpox ravaged the general population. In colonial times, most physicians were either self-trained or trained by another physician. No medical college existed in the colonies before the Revolution. Lack of knowledge of causes and cures of most diseases paired with the lack of effective medicines and painkillers, as well as instruments such as the thermometer and stethoscope, handicapped colonial doctors. The doctor's principal role was to provide comfort and support, set broken bones and prescribe herbal remedies. Theories of medicine at the time were based on the notion that disease was caused by an imbalance in bodily "humors," or fluids. The practice of bloodletting for almost any disease was universal. Doctors also employed emetics, diuretics and leeches. The cures often killed the patient more quickly than did the disease.

Like many of his contemporaries, John Carlyle's growing antagonism toward Great Britain began in 1755 during the French and Indian War. While the majority of people in the American colonies identified themselves as loyal Englishmen throughout most of the eighteenth century, the British looked down on America as a wilderness inhabited by a motley mix of renegades, malcontents, criminals, slaves and Indians that was unable

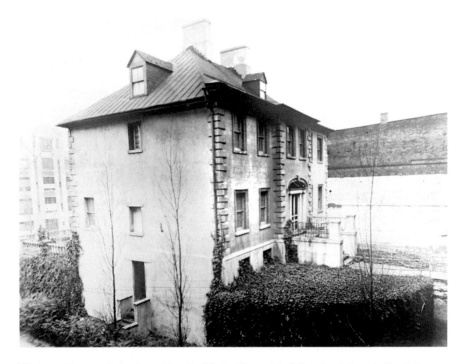

The grand home of merchant John Carlyle in Alexandria fell on hard times before being saved by preservationists. *Courtesy of the Library of Congress.*

to produce manufactured goods for itself and was culturally primitive. Appointed commissary of the Virginia militia in 1755, John Carlyle had a close view of the British attitude and complained that the British troops

> *by some means or another came in so prejudiced against us* [and] *our Country…that they used us like an enemy country and took everything they wanted and paid nothing, or very little, for it. And when complaints* [were] *made to the commanding officers, they* [cursed] *the country and inhabitants, calling us the spawn of convicts the sweepings of the gaols…which made their company very disagreeable.*

Relations between Great Britain and the colonies continued to deteriorate over the years. In 1774, the Fairfax County Committee of Safety was organized. Carlyle became a member. Risking everything, Carlyle warmly supported the Revolution. He died in September 1780 at the age of sixty during the darkest days of the war. John Carlyle is buried in the cemetery of the Old Presbyterian Meeting House in Alexandria.

In the Beginning

GENERAL BRADDOCK'S GOLD

One of Northern Virginia's must intriguing legends involves buried treasure, specifically the lost treasure of British general Edward Braddock. In 1755, war raged across the American frontier. The English colonies were locked in mortal combat with their age-old enemy, the French, and their Indian allies. In February 1755, the English general Edward Braddock landed at the port of Alexandria with one thousand British regulars. Braddock's expedition was just one part of a massive British offensive against the French in North America that summer. Braddock's misison was to drive the French out of Fort Duquesne (Pittsburgh) and destroy French resistance along the frontier.

Braddock's troubles started almost immediately. He could never get used to the terrain and distances in America. The Potomac River, which on a map looked like a highway leading far to the west, was made unnavigable by rocks and falls just a few miles above Alexandria. The expedition faced an enormous logistical challenge: moving a large body of men, equipment and heavy artillery across densely wooded and mountainous terrain 110 miles into western Pennsylvania. Heavy rains from April to June made the land between Alexandria and the fur-trading town of Winchester a sea of mud. The expedition progressed slowly because Braddock insisted in building a road to Fort Duquesne. In some cases, the column moved as few as two miles a day.

Arriving at the village of Newgate (renamed Centreville in 1798), only twenty-seven miles from Alexandria, the cannons and wagons became hopelessly mired in mud and clay. In an act of desperation, Braddock ordered some of the artillery buried. Taking aside a small group of soldiers, he buried two of the brass cannons after pouring the gold coins used to pay the troops into the open ends of the barrels. The mouths of the cannons were then sealed with wooden plugs.

The general carefully noted the location of the treasure: "fifty paces east of a spring where the road runs north and south." The road of which he spoke is now called Braddock Road, where it runs north to intersect U.S. Route 29-211 in Centreville, Virginia.

Braddock marched on to disaster in western Pennsylvania. Ambushed in the thick forests, the red-coated British were easy targets for the concealed French and Indians. The few trusted officers who knew the secret of the buried treasure were killed in battle. Finally, with General Braddock mortally wounded, the army managed to retreat. Braddock died on the night of July 13, 1755. His last words were, "Who would have thought it?"

General Braddock's papers were sent to England. Years later, an archivist found the account of the buried gold located in Virginia. A special committee was dispatched to search for the gold but returned to England empty-handed. To this day, it would seem, two brass cannons filled with gold lie beneath the soil of Virginia.

So here you have the legend of Braddock's gold. But where did the tale come from and how true is it? In 1982, Douglas Phillips and Barnaby Nygren wrote a monograph entitled *An Inquiry into the Validity of the Legend of Braddock's Gold in Northern Virginia*. Phillips and Nygren assert that they were unable to find any reference to General Braddock's treasure dating before 1954, when the article "A Buried Treasure" by Charles J. Gilliss appeared in the 1954 *Yearbook* of the Historical Society of Fairfax County. The popular media were quick to take up the Gilliss article, and numerous newspaper articles and book chapters have flowed from this original source. Problematically, the Gilliss article cited no references. The historical society's commentary on the Gilliss article at the time of its publication was: "Mr. Gilliss is a lifelong resident of Prince William County. Legends such as this are a most delightful part of our history."

When Phillips and Nygren compared historical documents to the Gilliss account, red flags went up. The Gilliss account, in many of its details, was not borne out by Braddock's own orderly book or accounts of the time by his officers. The army seems to have made good marching time and encountered no inclement weather. In short, there is no evidence to suggest that any difficulties were encountered in the location where the legend suggests the gold is buried. Phillips and Nygren next mapped out Braddock's line of march based on documents of the time, demonstrating that the column came nowhere near Centreville:

> *All the first hand accounts, based on diaries, orderly books, letters, maps, and court records…show that not only are certain elements of the legend probably false, but also that Braddock's troops took a march route which never brought them within ten miles of Centreville.*

Phillips and Nygren concluded:

> *While it is obvious to the authors that the probability of Braddock's Gold being buried in Fairfax County is virtually nil, the possibility, small as it may be, of gold being buried elsewhere along Braddock's route does exist, and in that may be the source of the Northern Virginia legend.*

This brings us to an interesting treasure legend from North Huntingdon Township in western Pennsylvania (as recorded on its website):

> *During the time of his expedition into the North Huntingdon area, General Edward Braddock camped one evening with his army near what is now known as Circleville…Braddock requested that the men wait until after the battle to get paid because a number of them would be killed. Therefore, he reasoned there would be fewer to divide the gold. The men voted in favor of Braddock's plan. Braddock then suggested they hide the gold instead of taking it into battle, lest it fall into the hands of the French and Indians.*

And so the legend lives on another day.

The Revolution and the Early Republic

With the end of the French and Indian War, relations between Great Britain and its American colonies began to deteriorate rapidly. Virginia played a leading role in formulating the grievances against the Crown. From the clash between Britain and America during the years of the Revolution were to emerge some of the greatest Americans of all time, including Northern Virginia's own George Washington.

Washington's preeminent fame at the end of the Revolution set the stage for the future development of Northern Virginia, for it was to George Washington that the country turned to select the site of a new capital city. The rise of the new federal city along the banks of the Potomac ensured that Northern Virginia would always be at the center of the nation's history. This was never clearer than in 1814, when a British army burned the great public buildings of Washington City and left the sky aglow. A British flotilla was soon to sail up the Potomac.

Northern Virginia and the Revolution

We casually celebrate the Fourth of July today, but some two hundred years ago the people of Virginia were engaged in a brutal life-or-death struggle. In 1776, Lord Dunmore, the royal governor, fought to keep the colony loyal to

the Crown. Only after a fierce battle ending in the destruction of Norfolk was Dunmore expelled. Three years of relative peace followed. Virginia's false sense of security was rudely shattered in 1779 by a British expedition under Admiral Sir George Collier that raided and occupied the port cities of the Tidewater. In 1781, the traitor Benedict Arnold and a British fleet ravaged the Tidewater, burning cities, seizing crops and destroying everything that they could find. Later in the year, Lord Cornwallis swept northward into Virginia and began to lay the country to waste. His only opposition was a small force under Lafayette.

The Virginia General Assembly abandoned Williamsburg, Richmond and Petersburg, fleeing to Charlottesville. The Virginians decided to assemble in mid-June. The British hatched a plan to capture or kill the entire assembly in one lightning raid that would crush all opposition. Lord Cornwallis chose the savage Banastre Tarleton and his battle-hardened cavalry to do the job. Tarleton came within a hair of capturing the assembly and Governor Thomas Jefferson. Fortunately, the Virginians received warning a few hours before the British arrived. Tarleton only managed to capture seven assemblymen, whom he later released as being of no importance. One of these Virginia representatives was Daniel Boone.

Using the same tactics of slash and run that they had employed throughout the war, the Americans began to wear Lord Cornwallis down. Lafayette, unwilling to engage the British in a pitched battle, remained unconquered. He shadowed Cornwallis, watching and waiting while his numbers increased and the British numbers dwindled. In June 1781, Cornwallis began to move slowly east through Richmond toward the Peninsula. Lafayette followed at a respectful distance while gathering reinforcements. Cornwallis finally halted at Williamsburg. The stage was set for the final allied victory at Yorktown.

The people of Northern Virginia played an important part in the Revolution. In 1774, for example, both Fairfax and Prince William Counties formed independent companies of volunteers, which elected their own officers and were outside the royal governor's command. As a measure of the Fairfax unit's expected permanence, its newly elected commanding officer, George Washington, ordered a special uniform from Philadelphia for the unit to wear. By June 1775, Washington had been appointed commander in chief of the Continental army. The buff and blue uniform chosen for the Fairfax Company was worn by Washington throughout the war and became identified in the public mind as the uniform of the Continental army.

By October 1775, a visiting Englishman named Nicholas Cresswell portrayed the people of Alexandria as cursing the king and all things English and being "ripe for a revolt." The final break came in July of the following year. Although no battles were fought in Northern Virginia, the war drew near in 1776. Lord Dunmore sent a flotilla up the Potomac to conduct raids. The people of Alexandria built two shore batteries containing sixteen cannons to defend the city. Large rowboats patrolled the Potomac.

In June 1777, Hessian prisoners were marched into the town of Dumfries. Twelve shallow graves in a family cemetery near Lake Montclair are said to be those of some of the Hessian prisoners.

In addition to giving a large number of soldiers to the cause of liberty, Northern Virginia provided two of its most brilliant commanders: General George Washington and General Henry ("Light Horse Harry") Lee, whose military genius was inherited by his son, Robert E. Lee. In April 1781, Lee headed off a British raid aimed at destroying the Neabsco Iron Foundry in Prince William County, which provided cannonballs and lumber for the Virginia navy.

It was also in April 1781 that the British warship HMS *Savage* anchored off Mount Vernon. The British raiders took seventeen of Washington's slaves from the Mount Vernon plantation. Lund Washington, a cousin who was watching over the plantation during the general's absence, went on board the *Savage*, took refreshments to the British officers and tried to negotiate the return of the slaves. He failed. A week later, Lafayette wrote to General Washington criticizing Lund's actions:

> *This being done by the gentleman who, in some measure, represents you at your house will certainly have a bad effect, and contrasts with spirited answers from some neighbors, that had their houses burnt accordingly.*

The general sent the unfortunate Lund a stinging letter rebuking him for "communing with a parcel of plundering Scoundrels."

Most of the citizens of Northern Virginia found themselves on the winning side at the end of the Revolution, but an unlucky few did not. Robert Bristow of Prince William County, for example, remained loyal to the Crown and had 7,500 acres confiscated. The tract was divided into 100-acre lots and sold at auction. The present town of Brentsville stands on this land.

The Revolution and the Early Republic

WASHINGTON'S RUNAWAY SLAVES

Historians have a difficult time with the story of George Washington and slavery. Washington was born into a society in which slavery was taken for granted, at least by the masters. At the age of eleven, Washington inherited ten slaves. Throughout his lifetime, he acquired many more, with over three hundred slaves living at Mount Vernon by the time of his death. The slaves were treated as economic assets of the farm. Contemporary accounts of Washington's behavior toward slaves are contradictory, with some accounts noting his severity and other accounts stating that "Washington treated his slaves far more humanely" than his neighbors. Ultimately, Washington's will instructed that all of his slaves were to be emancipated upon the death of his wife, Martha. Only one slave, William Lee, was freed outright in Washington's will. None was emancipated in his lifetime. Whatever George Washington's attitude toward owning slaves may have been, we know with certainty what at least two of his slaves thought of being owned by George Washington: they ran away, never to return.

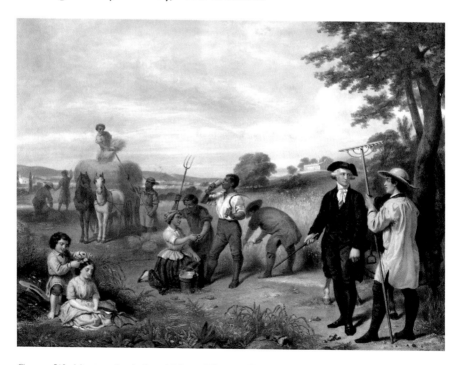

George Washington dearly loved Mount Vernon. There were over three hundred slaves working at the estate. *Courtesy of the Library of Congress.*

Born on the Gambia River around 1740, Henry Washington (real name unknown) was captured and sold into slavery sometime before 1763. He subsequently became the property of George Washington and was a groom in the stables at Mount Vernon. In November 1775, the royal governor of Virginia, Lord Dunmore, issued a proclamation offering freedom to any slave who would help put down the American rebels. That December, George Washington, commanding the Continental army in Massachusetts, received a report from his cousin Lund that Lord Dunmore's proclamation had stirred the passions of Washington's own slaves: "There is not a man of them but would leave us if they believed they could make their escape. Liberty is sweet." In August 1776, a month after the Declaration of Independence was signed, Henry Washington made his escape from Mount Vernon, making his way to the British lines and joining Lord Dunmore's all-black Ethiopian Regiment. With several hundred men under arms, the Ethiopian Regiment fought for the Crown and the freedom of all blacks in slavery under the regimental motto "Liberty to Slaves." Lord Dunmore's forces were overwhelmed in Virginia, and the Ethiopian Regiment disbanded. Henry Washington went on to serve in another Loyalist regiment, the Black Pioneers, under the command of Sir Henry Clinton, as they moved from New York to Philadelphia to Charleston and, after the fall of Charleston, back to New York.

Henry Washington was not alone in joining the British. Between 80,000 and 100,000 runaway slaves sought freedom within the lines of the British army. When the British evacuated Charleston, hundreds of desperate ex-slaves tried to embark on the departing ships. Some jumped from the docks and swam out to the last longboats ferrying passengers to the British fleet. Clinging to the sides of the longboats, they were not allowed on board, but neither would they let go; in the end, their fingers were chopped off.

In 1782, a provisional treaty granting the American colonies their independence was signed by Great Britain. As the British prepared for their final evacuation, the Americans demanded the return of runaway slaves under the terms of the peace treaty. The British refused to abandon black Loyalists to their fate. Some four thousand blacks who had served the Crown during the war, together with their families, were listed in "The Book of Negroes." Those lucky enough to make the list sailed to freedom in Canada and England. Among them was Henry Washington.

George Washington had another well-documented runaway slave, Oney Judge. More is known about Oney Judge than about any other Mount Vernon slave because she lived to an old age and was interviewed by abolitionist

newspapers in the nineteenth century. Oney grew up in service at Mount Vernon, eventually becoming Martha Washington's personal servant. In April 1789, Oney was one of seven slaves taken to New York City to work in the presidential residence. The capital shifted to Philadelphia in 1790, a city where slavery was most unpopular, and Oney went with the Washingtons to Philadelphia. In 1796, Martha Washington told Oney that she intended to give her to a granddaughter, Elizabeth Custis, as a wedding present. Oney was having none of this and fled from the Washingtons with the help of free black friends. She boarded a ship headed north and ended up in Portsmouth, New Hampshire.

Oney was eventually recognized in Portsmouth by friends of the president. Washington took immediate action to regain his property, writing to Joseph Whipple, the collector of customs in Portsmouth, asking him to "seize her and put her on board a Vessel bound immediately to this place, or to Alexandria." Whipple cautioned the president that such an action might create a riot in New Hampshire, which favored "universal freedom." Washington directed Whipple not to do anything that would "excite a mob or riot…or even uneasy Sensations in the Minds of well disposed Citizens." Two years later, Washington's nephew was on business in New Hampshire, where, in addition to other things, he hoped to arrange for the return of Oney to Virginia. He failed.

Under the laws of the land, Oney remained a fugitive for the rest of her life. She eventually married a sailor, had three children and lived the remainder of her life in New Hampshire, dying on February 25, 1848.

GEORGE WASHINGTON AND FREEMASONRY

Sitting high atop Shuter's Hill in Alexandria, once considered as the site for the U.S. Capitol, the Alexandria-Washington Freemason Lodge No. 22 dominates the local skyline—as well it might, being the lodge of none other than Worshipful Brother George Washington.

Started as craft guilds for stonecutters working on the great cathedrals of Europe during the Middle Ages, by the seventeenth century Freemason lodges had morphed into societies devoted to personal study, self-improvement and social betterment through individual actions and philanthropy. Freemasons were required to affirm their belief in a supreme being, but the interpretation

of the term was subject to the conscience of the candidate. By the end of the eighteenth century, Freemasonry had gained widespread acceptance among progressive social elites. During the late 1700s, Freemasons were responsible for spreading the ideals of the Enlightenment: the dignity of man and the liberty of the individual, the right of all people to worship freely, the formation of democratic governments and the importance of public education.

Freemasonry became very popular in colonial America. The earliest American lodges were the First Lodge of Boston, established in 1733, and one in Philadelphia, established about the same time. Benjamin Franklin served as the head of the fraternity in Pennsylvania, as did Paul Revere and Joseph Warren in Massachusetts. Other well-known Masons involved with the founding of America included John Hancock, John Sullivan, the Marquis de Lafayette, Baron Fredrick von Steuben, Nathanael Greene and John Paul Jones.

George Washington joined the Masonic Lodge in Fredericksburg, Virginia, at the age of twenty in 1752. His Masonic membership, like the other public titles and duties he performed, was expected from a young man of his social status in colonial Virginia. Not much is known of Washington's Masonic life during the quarter century following his induction into the fraternity. Tradition puts him in various military lodges during the time, but because of their traveling nature, there remains no record of his attendance.

Washington returned to Mount Vernon in 1783 after the Revolutionary War. He was invited to join Lodge No. 39 and later became the first worshipful master of the newly established Grand Lodge of Virginia (Lodge No. 22). He served some twenty months in this post. During his tenure as worshipful master of the Grand Lodge of Virginia, Washington was inaugurated president of the United States, becoming the first and only Mason to be president of the United States and master of his lodge at the same time.

President Washington took his oath of office on a Bible from St. John's Lodge in New York at his first inauguration in 1791. During his two presidential terms, he visited Masons in North and South Carolina and presided over the cornerstone ceremony for the U.S. Capitol in 1793, laying the cornerstone of the United States Capitol in Masonic garb, as chronicled by the *Alexandria Gazette* of September 25, 1793. In retirement, Washington sat for a portrait in his Masonic regalia, and in death, he was buried with Masonic honors.

George Washington's Masonic connection has been historically problematic for some groups. Various religious groups ban or discourage their members from being Freemasons. The denomination with the longest

history of objections to Freemasonry is the Roman Catholic Church. Even today, Catholics are admonished that "the faithful who enroll in Masonic associations are in a state of grave sin and may not receive Holy Communion." The objections raised by the Roman Catholic Church are based on the perception that Masonry encourages deism, which is in conflict with teachings of the church. A number of Protestant sects have denounced Masonry as well, stating, "The god of the lodge is not the God of the Bible." The anti-Mason position of some Muslim clerics is that Freemasons "work in the interest of Zionism and according to its instructions." Nor is criticism of Masonry confined to religious denominations alone. Conspiracy theorists, both today and throughout the last three centuries, have identified Freemasonry as an organization conspiring to achieve world domination or already secretly in control of world politics.

In Masonic terms, George Washington was "a just and upright Mason," a "living stone" who became the cornerstone of American civilization. In Washington's own words, "the grand object [of Masonry] is to promote the happiness of the human race."

The War of 1812

America was rushed into war. The so-called War Hawks in Congress, hungry to conquer Canada while England was preoccupied with war against Napoleon, whipped up patriotic passions and plunged the unready country into a conflict for which it was poorly prepared. The editor of the *Alexandria Gazette* warned, "What pledge have we that a naval force will not be sent to lay our rich maritime cities under enormous contributions or raze them to the ground?"

The town notables of Alexandria secured loans from three banks totaling $50,000 for the purpose of defending the Potomac River approach to the town. Alexandria banks also advanced the national government $35,000 for the purpose of reinforcing Fort Washington in Maryland, which lay six miles south on the river protecting the approach to Alexandria and Washington City. In February 1814, five cannons were mounted along the waterfront. By July 25, 1814, military men were still declaring the town inadequately defended.

On August 6, 1814, a British fleet consisting of nearly fifty vessels sailed into Chesapeake Bay. The Alexandria town and county militia were called

out en masse in late August and ordered to cross the Potomac, taking up positions between Piscataway and Fort Washington. They took all of the arms and artillery belonging to the town, leaving Alexandria defenseless.

The main British army landed at Benedict, Maryland. British forces routed American troops at the Battle of Bladensburg on August 24, 1814, and marched into Washington City. The British commander reported to London:

> *I reached [Washington] at 8 o'clock that night. Judging it of consequence to complete the destruction of the public buildings with the least possible delay, so that the army might retire without loss of time, the following buildings were set fire to and consumed: the capitol, including the Senate house and House of representation, the Arsenal, the Dock-Yard, Treasury, War office, President's Palace, Rope-Walk, and the great bridge across the Potomac: In the dock-yard a frigate nearly ready to be launched, and a sloop of war, were consumed.*

The glow from the burning city could be seen forty miles away in Baltimore. With the city of Washington in flames, twenty-two wagonloads of United States documents—including the Declaration of Independence, the Articles of Confederation, the Constitution, much of George Washington's correspondences and congressional and State Department records—made their way across the Potomac into Northern Virginia. Loudoun County served briefly as a temporary refuge for both the president and important state papers. The Constitution and other state papers were brought to a plantation called Rokeby, near Leesburg, where they were stored in a vaulted room in the cellar. President Madison established headquarters at Belmont, where he was the guest of Ludwell Lee. Local tradition holds that, since all of the government's documents were stored at Rokeby House, Leesburg was briefly the capital of the United States.

While Washington City smoldered, seven British warships under the command of Captain James Gordon (thought by some to be the inspiration for C.S. Forester's fictional hero Horatio Hornblower) appeared on the Potomac headed for the city. On August 27, the British fleet approached Fort Washington. The fort had twenty-six guns ranging from fifty-pounder Columbiads to six-pounder fieldpieces and over three thousand pounds of cannon powder. Nine guns were capable of firing downriver. Captain Gordon later reported:

> *A little before sunset the squadron anchored just out of gunshot; the bomb vessels at once took up their position to cover the frigates in the projected*

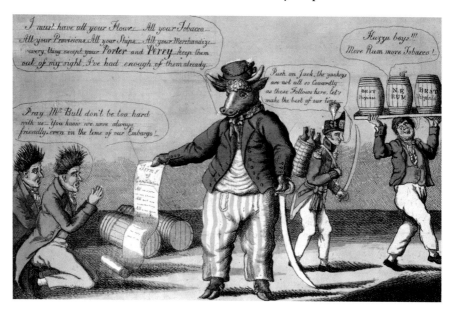

Many criticized the citizens of Alexandria for surrendering to the British without firing a shot during the War of 1812. *Courtesy of the Library of Congress.*

> *attack at daylight next morning and began throwing shells until about 7:00pm. The garrison, to our great surprise, retreated from the fort; and a short time afterward Fort Washington was blown up.*

The next morning the squadron paused in front of the fort and completed its destruction.

On the morning of August 28, 1814, a committee led by Alexandria mayor Charles Simms rowed south to meet the British and request terms of surrender. Refusing to give conditions, Gordon and his fleet arrived in front of Alexandria in the evening. The following morning, the British lined up their gunboats with cannons bristling at the ready.

At the mercy of the British squadron, the town council agreed to the enemy's demands. For the next five days, the British looted stores and warehouses of barrels of flour, hogsheads of tobacco and bales of cotton, along with wine, sugar and other items. The frustrated Virginia militia, camped on the outskirts of town, observed the British fleet. The town was almost burned when several militiamen slipped into town and tried to take a British midshipman prisoner. The midshipman escaped and sounded the alarm, sending British sailors scurrying for their ships. Mayor Simms quickly rowed to the flagship and was able to persuade the British that an

attack was not being launched by the militia but the incident was the work of a few hotheads.

While the British confiscated goods in Alexandria, American forces were setting up a battery on the river at White House Landing below Mount Vernon. On September 1, Captain Gordon sent two of his ships to fire on the battery to impede its completion, but by evening the Americans had five naval long guns and eight artillery fieldpieces in place. On September 6, the entire squadron engaged the battery, destroying all thirteen American guns within forty-five minutes. All seven British warships and twenty-one captured merchant vessels returned to the main fleet.

Captain Samuel Dyson, who had lost Fort Washington, was relieved of his command and ordered to his home in Alexandria. A court-martial found him guilty of abandoning his post and destroying government property. He was dismissed from the service. The secretary of war, John Armstrong, was forced to retire and abandon his ambition to become president because of his failure to protect the capital.

QUAKERS

People who look back wistfully to a time when harmony reigned in the land obviously don't know their history. Americans have always been a divided and contentious people. In the early days of the republic, it was the peaceful Quakers who brought dissension to Northern Virginia. The Quakers came to the region as part of a broader stream of immigrants from Pennsylvania in the 1730s and '40s. The number of Quaker churches grew rapidly. In the years during and after the American Revolution, Quaker beliefs and practices aggravated their neighbors and increasingly placed Quakers outside the mainstream of life. The Quakers believed that all people possessed an "inner light" that made them equally capable of receiving God's grace. This led them not only to reject slavery but also to actively work against it. Second, Quakers espoused pacifism, believing that it was wrong to take a human life. During the American Revolution, 8 percent of Virginia's male Quaker population of military age were disowned by their brethren for taking oaths of loyalty, paying war taxes, hiring substitutes for militia service or, in a few cases, actually joining the militia. Finally, Quakers believed that simplicity of spiritual truth should be reflected in

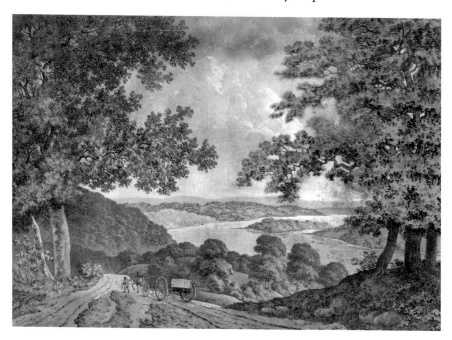

Washington in 1795. But was the area ever the peaceful paradise pictured by the artist? *Courtesy of the Library of Congress.*

daily life. From this conviction came their plain dress, simple and direct language and rejection of displays of wealth. Many Quakers believed that the ownership of slaves led masters to abandon simplicity in favor of sloth, luxury and arrogance. Black slaves became, for many Quakers, symbols of conspicuous consumption, a sign that their masters were more concerned with worldly than spiritual affairs.

Although some Quakers owned slaves before the Revolution, after 1776 Northern Virginia's Quakers were required to abandon slave owning or be disowned by their brethren. After ending slavery within their own community, some Quakers attempted to end it elsewhere in the United States. A number of Northern Virginia's Quakers took an active role in these efforts. In 1783, the Philadelphia Yearly Meeting appointed Quaker abolitionists Anthony Benezet, Warner Mifflin, James Pemberton and George Dillwyn to present a petition to Congress calling for an end to the slave trade, which was contrary to "every humane and righteous consideration, and in opposition to the solemn declarations often repeated in favour of universal liberty." Of the twenty Virginians who signed this petition, eighteen were from Northern Virginia. Congress rebuffed this and similar petitions in 1785 and 1786. Yet another such petition was submitted in 1790 and was again defeated, but not

before setting off a bitter debate in Congress between those who defended the Quakers' right to speak and those who attacked the Friends as a threat to public order.

In 1796, William Hartshorne, a prominent Quaker merchant of Alexandria, assumed the presidency of the "Alexandria Society for the Relief and Protection of Persons Illegally Held in Bondage," a local antislavery organization. In December 1796, the society hired a schoolteacher and established a Sunday school for free and enslaved black children. Within four months, the school had over one hundred students. The efforts of the Quaker abolitionists were generally unwelcome by their neighbors. In 1798, state legislation was enacted, directly targeting abolition societies in Virginia. Free persons who incited slaves to insurrection were to be punished by death, those who harbored slaves without the consent of the slaves' master were to be heavily fined and members of antislavery societies were disqualified as jurors in suits in which slaves sued for freedom. The sixty-one members of the Alexandria abolitionist society continued their labors to ameliorate the conditions of slavery.

In 1800, a slave insurrection in Richmond, known as Gabriel's Rebellion, sparked widespread fear among whites. Elisha C. Dick, a prominent doctor and public official in Alexandria, petitioned the governor to enact "immediate legislative measures...to restrain if not entirely suppress the schools supported by [antislavery advocates]." The doctor described the schools as "constantly inculcating natural equality among the blacks of every description; they are teaching them with great assiduity the only means by which they can at any time be enabled to concert and execute a plan of general insurrection." Legislation regulating slaves became more repressive. The "Alexandria Society for the Relief and Protection of Persons Illegally Held in Bondage" was dissolved in 1801.

Industrious Quaker communities continued to thrive in Northern Virginia. In 1846, a small group of Quakers from Pennsylvania and New Jersey bought thousands of acres of timberland near Woodlawn Plantation and the Mount Vernon Estate in Fairfax County. The timber was supplied to a prominent Quaker shipbuilder in Philadelphia, and a farming community without slave labor was established. The leaders of the experiment divided the property and sold plots to other Friends from Pennsylvania and New Jersey. A steady influx of settlers moved into the community at Woodlawn, all of them dedicated to the principle that they would farm without slaves. The Quakers were devoted to the idea that a venture could be economically sound as well as ethically right.

DUELING

Today's partisan bickering seems mild compared to the political roiling of the early Republic, when policy differences could end up with bullets being exchanged in the early morning hours, as was the case here in Northern Virginia.

John Randolph was a Virginia congressman and one of the primary spokesmen of a faction of the Democratic-Republican Party founded by Thomas Jefferson. Randolph's faction wanted to ensure social stability with minimal government interference and decried "creeping nationalism." He once said, "I am an aristocrat. I love liberty, I hate equality." In 1825, he entered the Senate. In 1826, Randolph made a fiery speech in the Senate denouncing the foreign policy of President John Quincy Adams. Specifically, he was against the president sending a delegation to the Panamanian Congress of Latin American Republics. Randolph railed against the president and the secretary of state, Henry Clay, intimating that Clay was a scoundrel. The secretary of state took offense at this insinuation and challenged Senator Randolph to a duel.

Dueling politicians were not rare in the young republic. Andrew Jackson fought more than one hundred duels before becoming president. In those days, if you called the president a liar you were likely to have to back up your words with a sword or a dueling pistol. Both Clay and Randolph had been involved in previous duels. Clay fought a duel while a member of the Kentucky state legislature. Randolph fought a duel while a student at the College of William and Mary and again in 1815 while in the House of Representatives. By 1826, dueling had become illegal in Virginia, but the little matter of the law was not about to deter lawmakers Clay and Randolph from fighting.

Dueling in America flowed down from the ancient practice of trial by combat developed in the Middle Ages. A test of arms between two opponents was deemed the surest way of knowing which party God favored in a dispute. By the time of the Clay-Randolph duel, dueling was regulated by a widely accepted set of rules known as the Code Duello, first codified in Ireland during the late eighteenth century. The Code Duello laid out in excruciating detail the courtesies, responsibilities and order of events of the proposed combat. The typical duel started with a perceived insult. The insulted person issued a challenge through his second. The second was usually a close friend of equal social rank who, if the insulted person for some reason was unable

to fight the duel, was expected to fight it for him. The second contacted the second of the other party and worked out the details of time, place and weapons to be used. A duel could be stopped by an apology or after honor had been satisfied.

The Clay-Randolph duel took place on Saturday, April 8, 1826, in a thick forest near what is today a road leading from Chain Bridge to Langley and McLean. This area was selected because Randolph wanted, in case the worst happened, to die "on the sacred soil of the Old Dominion." The two antagonists, together with their seconds and supporters, arrived on time. Randolph and Clay were given their pistols and took up their positions at ten paces. At this point, Randolph's pistol accidentally discharged. He explained to the assembled company that he was not used to the gun's "hair trigger." Clay accepted the explanation. Randolph was provided another gun, and once again the two men took up their positions. At this point, the secretary of state took careful aim and shot Senator Randolph—straight through the hem of his coat. The uninjured Randolph fired his pistol into the air

The most famous dueling ground in America in nearby Bladensburg, Maryland. *Courtesy of the Library of Congress.*

and then rushed forward to shake Clay's hand. Honor had been satisfied, although Randolph remarked to Clay, "You owe me a coat, Mr. Clay."

Although the Clay-Randolph duel has an air of posturing and comic opera about it—much form and very little substance—such was not always the case when it came to duels. They could in fact be deadly. Francis Conway and William Thornton were both attracted to Nellie Madison, the niece of President James Madison. Their rivalry led to a duel in 1803 near Fredericksburg. Once again a challenge was issued, seconds arranged the details, pistols were loaded and handed out and the duelists took their positions. At the command, "Fire!" two shots rang out almost simultaneously. Each man was hit near his bladder. Each man died in agonizing pain within a few hours. Honor had been satisfied.

Dueling continued in Virginia into the 1870s.

A House Divided

From the earliest days of the republic, slavery had been the great indigestible of American life. For decades politicians had found temporary compromises that averted a violent collision, but ultimately only a long and bloody war could decide the issue. The Civil War was the bloodiest war in American history. Some 600,000 men died. As a percentage of the population, this number equates to 5 million people in today's America.

Northern Virginia suffered during the war. Crops were trampled. Fences were chopped up for firewood. Livestock was requisitioned. Barns, outbuildings and private homes were occupied by the armies. Many skirmishes and two major battles were fought on the doorstep of the nation's capital. The sights and sounds of war and preparation for war were constant for four long years. Ultimately, Northern Virginia became the great marshaling depot for the supplies and men that would move south to capture Richmond and end the war. By 1865, after twenty-six major battles and four hundred smaller engagements on its soil, all of Virginia lay prostrate.

Slavery Days

In England, gifts were presented to servants, tradesmen and other service workers on December 26, Boxing Day. This custom became popular in the

OH CARRY ME BACK

TO OLE VIRGINNY.

Virginia had the largest slave population in the Union and greatly feared Northern interference in the South's "peculiar institution." *Courtesy of the Library of Congress.*

South. Slaves were given a gift box. Usually their gift box contained money or clothing. Because of this custom, slaves and servants especially looked forward to the holiday. Even the severest masters gave their slaves Christmas Day to celebrate. Most gave them one or two additional days.

Other than Christmas, however, a slave had very little to look forward to. A slave could be whipped or sold at the whim of the owner, could not make legally binding contracts of any kind and could be hunted down like an escaped criminal if (s)he left the owner's property without permission. Landon Carter of Pittsylvania used young slave women as gambling "chips," requiring them to sleep with the game's winner.

The vast majority of male slaves worked as farmhands. Others worked as laborers, waiters, blacksmiths, drivers and servants at inns. Although the free labor of the slave was the most obvious economic benefit to the owner, slaves were also a liquid asset. The selling or hiring out of excess slaves to the labor-hungry cotton plantations of the Deep South was a source of revenue for many slaveholders in Virginia. A slave woman was commonly esteemed less for her laboring qualities and more for those qualities that gave her value as a broodmare. In 1857, a Richmond newspaper price list quoted the price of a "number one man...extra (fine)" at $1,450–$1,550; "Good" was quoted at $1,200–$1,250. Women sold for 20 percent less.

To appreciate the hold that slavery had on the sense of economic well-being of both the slave-owning and the general populations, it is important to recognize the economic pervasiveness of slavery in Virginia. In 1860, Virginia had the largest number of slaves of any state in the Union. One

out of every three white families in what is modern-day Virginia owned slaves, making it similar to such Deep South states as Alabama, Louisiana and Georgia. A slave worth $1,800 in 1860 would have a current value of some $30,000, the price of a new car. So even a modest slave owner would have a large economic stake in perpetuating the institution.

Non–slave owners, without the motive of economic self-interest blinding them, could recognize the inherent problem of slavery in Virginia. The Benevolent Society of Alexandria for Ameliorating and Improving the Condition of the People of Color, for example, published the following statement:

> *These enormous cruelties cannot be practiced among us, without producing a sensible effect upon the morale of the community: for the temptation to participate in so lucrative a traffic, though stained with human blood, is too great to be withstood by all; and even many of those who do not directly participate in it, become so accustomed to its repulsive features, that they cease to discourage it in others.*

Even a cursory examination of the writings of the time suggests that slavery led many slave owners not to empathize with the humanity of slaves. The *Alexandria Gazette* of January 2, 1850, for example, put reward notices for a runaway slave named Wallace, age twenty-one, and a missing black horse, age seven, side by side, as though these notices belonged in the same category.

Slave narratives, such as one written by runaway slave Henry Watson in 1849, speak to the human tragedy of slavery. Watson describes how forced separation from his mother set him on a path of resistance:

> *A slave-dealer drove to the door in a buggy, and my mother was sent for to come into the house; when, getting inside, she was knocked down, tied, and thrown into the buggy, and carried away…I felt as if all hope was gone; that I was forsaken and alone in this world. More forcibly did I then feel the galling chains of slavery, the cruelty and barbarism arising from it, than I ever have since. I resolved, however, to bear with all patiently, till I became large enough to run away, and search for my mother.*

Foreign observers beheld scenes of degrading human misery, which were common on Virginia roads as thousands of slaves were transported to the Deep South:

A House Divided

Before we had proceeded far, Mr. Denton gave orders for us to stop, for the purpose of handcuffing some of the men, who, he said in a loud voice, "had the devil in them." The men belonging to this drove were all married men, and all leaving their wives and children behind; he, judging from their tears that they were unwilling to go, had them made secure.

Slave discipline was enforced sharply. Unruly slaves were taken to be whipped. After the whipping, a compound of water, salt and mash was pressed into the wounds. The screaming could be heard for two miles around. The law required the sheriff to administer punishment, but the task usually fell to the plantation owner who had little interest in having anyone observe the punishment being meted out.

Although only about one-tenth the size of the slave population, Virginia had the largest free black population in the Union (some thirty thousand

Alexandria was a busy slave-trading center. Here a slave stands in front of a slave pen on Duke Street. *Courtesy of the Library of Congress.*

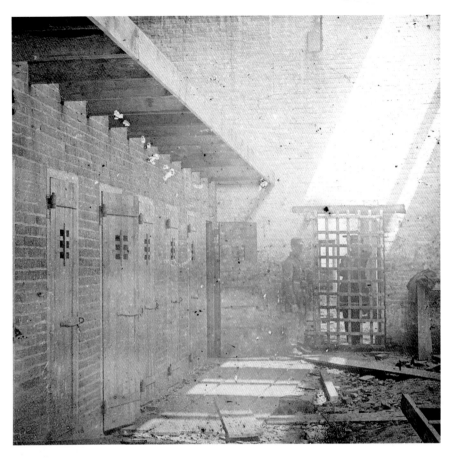

The interior of the Duke Street slave pen in Alexandria after capture by the Union army. *Courtesy of the Library of Congress.*

plus). Freedom was the greatest gift a master could bestow upon a slave, but the situation of the free black was only a little better than that of the slave. Free blacks could not vote in Virginia. They were required to register every three years and to pay for certificates of freedom. It was unlawful for free blacks to organize their own schools. Free blacks were feared and mistrusted. They were accused of being unwilling to work, of spreading discontent among the slaves and of causing a disproportionate amount of crime. Several Virginia governors advocated that all free blacks be forcibly expelled from the state. The assembly did not enact this legislation but did pass laws providing for voluntary reenslavement.

Despite stifling restrictions, many free blacks managed to improve their lot. A freed slave named Jim Robinson, the bastard son of Landon

Carter of Pittsylvania, operated a drover's tavern along the Alexandria and Warrenton Turnpike. Eventually, he was able to purchase his wife and three of his five children, as well as buy several hundred acres of land. He was unable to purchase his sons Alfred and James, both of whom were talented stonemasons, had been sold south and eventually ended up in New Orleans. James's fate is unknown, but Alfred returned to Northern Virginia in 1888.

GUNS ALONG THE POTOMAC

In the hazy light of a hot summer morning you can see the rippling shoreline of Maryland from the abandoned Confederate gun emplacements. This is history in the raw, a place called Possum Nose, a long-abandoned and forgotten Civil War site on the Potomac River. Earthworks, once built to protect cannons, watch the river blankly, while overgrown trenches await a Union attack that will never come. The remains of a powder magazine and scattered hut sites can be found in the deep woods, but these are the only reminders that Washington was once held hostage.

Even before Virginia became part of the Confederacy, Northern Virginians realized the opportunity they had to "strangle" Washington by erecting land batteries on prominent points along the Potomac. The decision to do so was finally reached in August 1861, while the Union army lay paralyzed after its defeat on July 21, 1861, at Manassas in the first major land engagement of the war. A strong battery was built at Evansport, at the mouth of Quantico Creek, some thirty-five miles south of Washington, on what is today the Quantico Marine Corps Base. Smaller batteries were erected at Possum Nose and Freestone Point, also in Prince William County. In all, there were thirty-seven heavy guns placed along the river supported by five infantry regiments. The Confederates also used a captured steamer, the CSS *City of Richmond*, berthed in Quantico Creek, to terrorize smaller craft on the river.

If a strong force of Union ships had been patrolling the Potomac at the beginning of August, it would have been impossible for the Rebels to construct or maintain gun batteries on the banks of the river. Once the three Rebel batteries supported by troops were dug in, however, it was considered to be almost impossible to capture the positions by assault.

Washington was shaken. The capital was proud of its busy wharves, where twenty new warehouses had been constructed. With the completion of the

first Confederate battery, trade began to suffer. The once busy wharves fell idle. Trade came to an abrupt halt. Shortages developed and prices soared. Occasionally, a ship would run the Southern blockade, but only the little oyster pungies docked with any regularity.

The Confederate defenses effectively closed the Potomac River. All ships carrying U.S. government shipments were directed to go to Baltimore to unload. Those ships not carrying government stores that attempted to run the batteries were subjected to a hail of fire for a distance of about six miles. Even the fastest ships could be kept under constant fire for almost an hour. Unfortunately for ships trying to run the Confederate gauntlet, the river's deepest channel swerved close to the Virginia shore just at the point where Rebel batteries were mounted.

A fight between Union and Confederate forces over a schooner carrying wood to Washington was typical of the military engagements that took place on the river. The schooner had made its way upriver under easy sail, but the wind dropped opposite the mouth of Mattawoman Creek. The Confederates spotted its condition and opened a brisk fire from the battery at Possum Nose. The crew dropped anchor and swam for the Maryland shore. Rebel troops boarded the ship and set it on fire. A few Union soldiers rowed out in a small boat, boarded the schooner and put out the fire. The Rebels opened fire on the schooner once again. One shell went through the sail, while a percussion shell exploded fragments on both sides of the schooner. Finally, beleaguered Union soldiers were able to tow the schooner out of danger.

The Confederate blockade was so successful during the fall and winter of 1861–62 that a foreign correspondent reported that Washington was the only city in the United States that really was blockaded. The blockade became so frustrating to the North, both in terms of morale and diplomatic embarrassment, that President Lincoln issued a direct order for action: "Ordered, That the Army and the Navy cooperate in an immediate effort to capture the enemy's batteries upon the Potomac."

Lincoln's order was never carried out, for on March 9, 1862, General Joseph E. Johnston ordered a general retreat of Confederate forces to defensive positions farther south, along the Rappahannock River, to forestall a Union drive on Richmond. Within two days, the batteries were evacuated and the CSS *City of Richmond* burned in Quantico Creek.

When Union troops occupied the Confederate positions, they found well-built log huts, some with wooden floors and roofs and a few boasting glazed windows. The retreating Confederates had left large quantities of supplies behind, and the camps were quickly looted by the Federals. Boats were

brought over from the Maryland side and loaded with toothbrushes, buttons, blankets, tobacco, shovels and spades, wheelbarrows, campstools, powder and flasks, shot and cap boxes. Some soldiers of the First Massachusetts Regiment came upon some fresh graves marked with warnings against disturbing the dead. The Yankee soldiers ignored the warnings and began digging. Instead of bodies they found new tents, uniforms, well-equipped mess chests and a variety of tools and other equipment.

Some evidence of the blockade still exists. A restored site can be seen at Freestone Point in Leesylvania State Park. Evidence also remains at Possum Nose. The unrestored earthworks here remain in excellent condition. The largest, overlooking the river from a seventy-five-foot hill with cliff-like banks, housed three guns. Smaller emplacements flank the main battery. Behind the batteries, running the entire width of Possum Nose, are winding rifle pits. The Fifth Alabama Infantry Battalion and one company of the First Tennessee were stationed at Possum Nose, and hut sites are still visible.

Despite the growth of Northern Virginia in the last century, many little-known Civil War sites dot the countryside, haunting reminders of that tragic war.

MOSBY'S CONFEDERACY

Because most of the fighting during the Civil War occurred in the South, the Confederacy often resorted to unorthodox methods in fighting the war. One expedient was the organization of bands of armed irregulars who were given license to carry out guerilla warfare behind enemy lines. On April 21, 1862, the Confederate Congress authorized the formation of bands of "partisan rangers." Native to the area, and intimately familiar with every hill and stream, the partisan rangers staged daring hit-and-run attacks against the vastly superior Union forces. Fed and shielded by sympathetic locals, the guerillas were a major irritant to the Union army.

North central Virginia became the preserve of one of the most dashing figures of the war, John Singleton Mosby. Mosby grew up in the shadow of the central Blue Ridge, attended the University of Virginia and practiced law in southwest Virginia. He signed up for the Confederate service shortly after the firing at Fort Sumter. By the summer of 1861, he was part of Stuart's cavalry. He served as Stuart's scout throughout much of 1862 and accompanied him on his Fairfax raid in December of that year. When Stuart

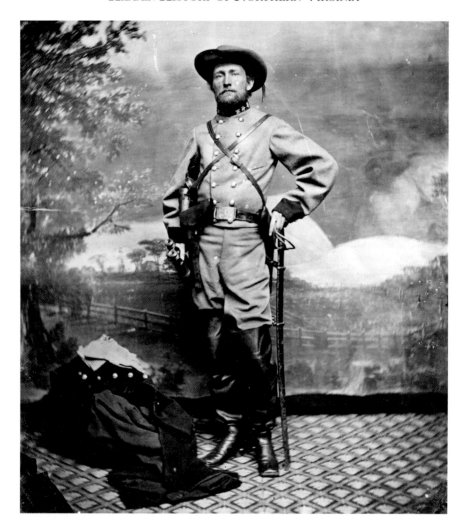

The daring Rebel raider John S. Mosby. *Courtesy of the Library of Congress.*

rode out of Fairfax County, Mosby, with nine men, was given permission to remain behind.

Northern Virginia was a region of small and scattered communities set amid gently rolling hills. It was an ideal area for cavalry operations, and in the last three years of the war Mosby's horsemen so dominated activities there that it was often called Mosby's Confederacy. Mosby was everywhere. He destroyed railway tracks. He robbed sutlers and Union paymasters. He captured pickets and shot down stragglers. Mosby, with a price on his head, crossed Long Bridge into Washington City in the full light of day. In Washington, he

hobnobbed with Union officers at the bar of the Willard Hotel and returned unharmed to Virginia. On one occasion Mosby stopped ladies on their way to Washington and sent a lock of his hair to President Lincoln, accompanied by a note expressing regret that he could not deliver it himself.

With fewer than 250 men, Mosby immobilized 30,000 Union troops and kept them from frontline duty. His command, often consisting of fewer than 50 men, captured thousands of Union troops, horses and mules. The Union army was camped around Washington in a gigantic protective circle. Well beyond the main army camps, a great ring of picket posts was established. Mosby began eliminating these first. On dark nights, his men would slip into and around these isolated posts where, if seen, they were taken for Union troops. Then, on a given signal, the Confederates would suddenly rush in with their revolvers, cover the small Union garrison and, most often without firing a shot, take the Yankee troops prisoner, confiscating their arms and horses. Mosby's little command began an almost daily series of small raids.

Soon civilians in the area became conscious of the Mosby magic, and many offered to enlist under the Confederate law, which authorized the creation of guerilla bands. While the Confederacy regarded Mosby and his irregulars as patriots, from the viewpoint of Washington and the Federal troops the guerillas were no better than highway robbers, a position that was substantiated by the fact that under Confederate law Mosby's guerillas were permitted to keep the spoils they seized from the Union.

Mosby's most daring exploit was the capture of General Edwin H. Stoughton in Fairfax Court House. Stoughton, the son of a prominent Vermont politician, had been made a brigadier general before his twenty-fifth birthday. The general was a vain man who loved rich living and beautiful women and surrounded himself with both in the comfortable two-story brick residence that he set up as his headquarters. Around him, quartered in other homes of the community, were his staff, aides, couriers and a guard of two hundred men. All the conveniences allowed an outpost officer were his. There were fine horses, carriages, silver and servants, as well as the finest food and wine.

One chilly March night in 1863, as the heavy rains pelted the pickets that had been stationed far from the general's headquarters, Stoughton entertained a glittering assembly of beautiful women, brother officers and foreign visitors out from Washington to see the war up close. Dancing and gaiety abounded, and the champagne flowed freely. Soon, the rolling hills around Fairfax Court House echoed with the sounds of merriment.

Midnight approached. The gaiety grew louder and the guests more oblivious to the war and weather conditions outside. After all, the nearest

Rebel forces were twenty-five miles away, there was the line of pickets to prevent a sudden dash on headquarters and the Virginia mud was so thick that it made an attack out of the question.

At 2:00 a.m. the last reveler fell into bed. Then came the noises of cavalry splashing in on the soupy road. The sentry at the center of the village heard the horses but continued to walk his beat. That would be Yankee horsemen, he reasoned—no Rebel troops could be within miles. The cavalry, thirty in all, rode into town and divided into three groups. The sentry continued his tiresome tread. He was concerned but not alarmed. And then, in the drizzling faintness of the lamp, he found himself staring at the barrel of a big Colt six-shooter.

Lieutenant Prentiss, Stoughton's aide, was awakened by shouts that there were dispatches outside for the general. When the aide opened the door, six men walked in, and a small wiry man with a plume in his hat stuck a gun in the aide's ribs. That man was Mosby. Mosby walked upstairs and found the half-drunk General Stoughton lying on his side snoring. Mosby lifted up the general's nightshirt and slapped him on the behind.

"Get up, General, and come with me," Mosby ordered.

"What is this?" the general asked. "Do you know who I am?"

"I reckon I do, General. Did you ever hear of Mosby?"

"Yes, have you caught him?"

"No, but he has caught you."

As Mosby's raiders rode out of Fairfax Court House they took with them, besides General Stoughton, two captains, thirty privates and fifty-eight horses. Mosby marched his prisoners to Culpepper, where they were turned over to General J.E.B. Stuart.

Mosby continued his activities unabated right to the end of the war, when he gathered his men one last time and disbanded, never officially surrendering to Federal forces. John Singleton Mosby went on to become a distinguished railway lawyer (and attorney to the father of George S. Patton). He died in 1916 at the age of eighty-three.

INCIDENTS OF WAR

It is often forgotten that it was not a foregone conclusion that Virginia would join the Confederacy. Although South Carolina and six other states in the lower South seceded in late 1860 and early 1861, before the inauguration of

Abraham Lincoln, those in favor of preserving the Union were initially in the majority in Virginia throughout the long winter months of 1861. Sentiment shifted abruptly when President Lincoln issued a call for men to suppress the rebellion after the attack on Fort Sumter in April. Fort Sumter fell on April 14, and on April 17 Virginia adopted an Ordinance of Secession in the form of a repeal of Virginia's ratification of the U.S. Constitution, to take effect upon ratification by the vote of the people. This election took place on Thursday, May 23, 1861, and Virginia seceded from the Union.

Long before the sun rose on Friday, May 24, Union troops were ordered to seize Alexandria and Arlington Heights. By 2:00 a.m., the New York Zouaves were rowing across the Potomac toward Alexandria. They docked along the waterfront and quickly made their way up King Street, unopposed by Confederate troops. Colonel Elmer Ellsworth led his men down the empty street until he came to the Marshall House, a prominent hotel flying a Confederate flag so large that President Lincoln could see it from the White House with a telescope. Ellsworth and his men went inside and hurried to the roof. Ellsworth cut down the flag and tucked it under his arm. In a shadowy hallway, the proprietor of the hotel, James Jackson, sprang out and shot Ellsworth, only to be shot in the head and bayoneted by one of Ellsworth's soldiers. Civil war had come to Northern Virginia.

On Friday afternoon, miles away at Fox's Mills, north of Fairfax Court House, seventeen-year-old Sally Summers was minding the afternoon recess in front of her schoolhouse when she saw a surrey coming down the road from the direction of Alexandria. The driver was her uncle, Amos Fox. As he passed, he shouted, "You better dismiss your school right away and go home to your mother. The Union army is advancing!"

In June 1861, both sides sent scouting parties into the countryside. The Union cavalry raided Fairfax Court House on June 1. Another bloody skirmish took place at Vienna on June 17.

Northern Virginia was not a monolithic society in 1861. Alongside aristocratic families were merchants and small farmers, poor whites, free blacks, slaves, Quakers and hundreds of enterprising and ambitious Northerners. During the first few years of the war, many parts of Northern Virginia became a no man's land in which Union and Confederate troops and sympathizers spasmodically and violently struggled for control.

The first major battle of the war was fought at Manassas on Sunday, July 21, 1861, resulting in a rout of the Union army. The Summers family, whose house was in the path of the retreating soldiers, woke up to find bales of blankets and uniforms in the yard, along with barrels of fish, flour and

The Marshall House in Alexandria flew a huge Confederate flag visible to President Lincoln in the White House if he used a spyglass. *Courtesy of the Library of Congress.*

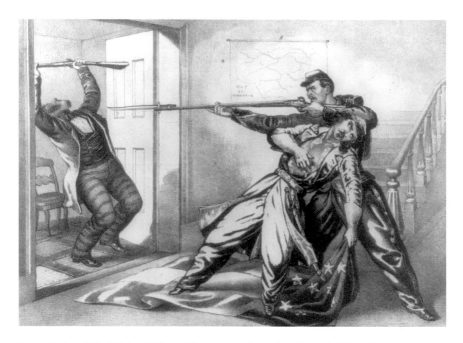

James Jackson killed Colonel Elmer Ellsworth and was then instantly killed. Both became martyrs to their causes. *Courtesy of the Library of Congress.*

beef tongues, and even a crate of champagne, all left behind in the panic of retreat.

By August, advanced elements of the Confederate cavalry were encamped on Munson's Hill within sight of the unfinished Capitol dome in Washington City.

As the struggle surged across Northern Virginia during the next four years, many curious reminders were left behind for future generations to ponder. Near the city of Fairfax, for example, the historic mansion Blenheim boasts the largest collection of Civil War graffiti in the nation. Blenheim was a new and luxurious home at the beginning of the war, having just been completed in 1859. During the course of the war, the Union army occupied the property on three separate occasions, with at least twenty-two different regiments of the Union army using the house at one point or another. For almost a year, Blenheim was used as a convalescent hospital. The Union soldiers passing through Blenheim left a "diary on walls" providing insight into typical soldier life during the Civil War. One soldier from the Fourth New York Cavalry wrote along the walls of a staircase:

> *First month's hard bread, hard on stomach.*
> *Second month, pay day. Patriotic-hic Ale. How we suffer for lager.*
> *Fourth month: no money, no whiskey, no friends, no rations, no peas, no beans, no pants, no patriotism.*

Another poignant reminder of the war is the gravestone of Bradford Smith Hoskins, "Late Capt. in her Britannic Majesty's Forty-Fourth Regiment," a British officer fighting for the Confederacy under the command of Colonel John Singleton Mosby. The grave of this British officer, buried so far from home, is in the small cemetery of the Greenwich Presbyterian Church in Prince William County. Mosby described the engagement in which the thirty-year-old Englishman died:

> *Captain Hoskins, an English officer, was riding by my side. Hoskins was in the act of giving a thrust with his saber when he was shot...Hoskins' wound was mortal. When the fight was over, he was taken to the house of an Englishman nearby, and lived a day or two.*

The house in question was called the Lawn and was owned by Charles Green, himself an Englishman. Green preserved the house from occupation

or destruction by the Union army by flying a British flag over the property throughout the war and proclaiming it neutral territory. It was not unusual to find British officers visiting or even fighting with the opposing armies. Colonel Sir Percy Wyndham, for example, commanded the First New Jersey Cavalry and was Mosby's arch nemesis.

THE HARD HAND OF WAR

During the four years of the Civil War, twenty-six major battles and four hundred smaller engagements were fought in Virginia. Two of the Civil War's great battles, First and Second Manassas, were fought in Northern Virginia. Few stop to think about the impact these battles had on civilians living in the area.

In 1860, there were 125 households in the vicinity of Manassas Junction. Most of the 548 whites and 45 free blacks were farmers or farm laborers. Most of the whites were not slave owners, but there were some sizeable estates with slave populations. The largest slaveholder in the area was William Weir of Liberia plantation who owned some 80 slaves. Clover Hill plantation had 14 slaves. Blooms Hill plantation had 20 slaves. Moor Green plantation was owned by the extremely cruel Redman Foster. Foster is said to have killed one of his bastard babies by a slave mistress because it was deformed. The outright murder of a slave was illegal, but prosecution of a slave owner would have been difficult.

At 4:30 a.m. on April 12, 1861, Confederate gun batteries opened fire on Fort Sumter in Charleston Harbor. The Civil War had begun. In May, Virginia seceded. On May 24, Federal troops seized Alexandria and Arlington Heights. Private Edgar Warfield, a native of Alexandria, was one of the Confederate soldiers who evacuated the city just ahead of the oncoming Union army. The Alexandria men boarded a train and were hauled to Manassas Junction. There was plenty of activity at Manassas Junction, with trains from the south constantly bringing in fresh troops. The arrival of the Confederate army had little direct impact on the lives of civilians in the area, who continued to devote themselves to the essential tasks of making a living. Everyone knew, however, that the two opposing armies must soon clash. Finally, on July 16, the great Union army marched out of Washington City to meet the Confederates at Manassas Junction. On July 21, 1861, the two great armies grappled.

On that day, eighty-four-year-old invalid Judith Henry lay in her bed as the battle began around Pittsylvania, her childhood home. Shells from Union artillery began to fall around the widow's house, Spring Hill. Mrs. Henry's two sons, shocked to find Union troops on their doorstep, decided to move their mother to safety. Mrs. Henry was unwilling to leave, but after several shells struck the house, the terrified woman gave in. The two sons placed the old woman on a mattress and carried her out of the house, intending to carry her to the Reverend Compton's house, about a mile away. The small party was soon caught in the open in the midst of a furious battle. Terrified and hysterical, the old woman begged to be taken back to her own home. The three Henrys returned to the house, and Mrs. Henry was returned to bed. She was only there a short time before a shell burst in the room where she lay. She was struck by seven shell fragments and lived for several agonizing hours, dying about nightfall. Rosa Stokes, a young slave who had been caring for the old lady, was wounded by the same shell that killed Mrs. Henry.

At nearby Folly Castle plantation, Betty Leachman put her five small children under a large sideboard, where they stayed huddled all day. The house was struck by cannonballs several times. Early on the morning after the battle, young Mr. Henry made his way to Folly Castle and asked Betty and her sister-in-law to return with him to prepare Mrs. Henry's body for burial. They went with him, cutting across fields strewn with dead soldiers.

The Lewis family of Portici found themselves at the center of the battle. Confederate officers notified the Lewis family that a battle was imminent and that their house would be exposed to fire. They evacuated, taking everything they could with them, but left valuable and heavy furniture behind. The furniture was stored in a small room in an angle of the house, and the room was securely nailed shut. The only shot that struck the house during the battle struck this room and destroyed all of the furniture. Furniture was a trifling matter, however. Fannie Lewis was in her ninth month of pregnancy and went into labor as they began to evacuate the house. Servants found a nearby ravine and dug a small earthen hollow into the bank. They covered this with greens. It was here that Fannie Lewis delivered her first baby, John Beauregard Lewis.

After the battle, Portici became a grisly field hospital. The wounded, dead and dying covered every floor in the house. There were two piles of amputated legs, feet, hands and arms, all thrown together. From a distance they looked like piles of corn. Many of the feet still had boots on them. Wounded men lay on tables while surgeons carved away like farmers in butchering season.

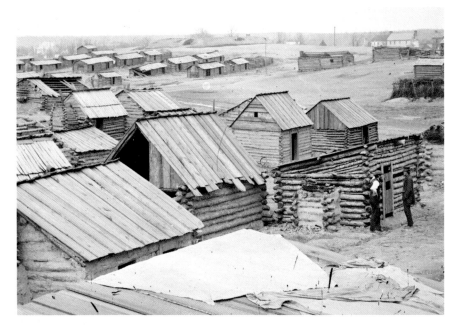

The Confederate winter quarters at Manassas, Virginia, 1861–62. *Courtesy of the Library of Congress.*

After an interlude of a little over a year, the horrors of war again returned to Manassas in August 1862 with the Second Battle of Manassas. After the second battle, Manassas faded into obscurity. Times were now very hard for the civilian population. There were no real horses left, only those that were battle-scarred, lame or blind. Women were forced to run farms with only the help of old people and children. To make matters worse, the farmers ran short of tools and implements, for it was impossible to replace the metal parts of plows, wagons, hoes and scythes.

In April 1865, peace finally came to Virginia. The area around Manassas Junction was a scene of utter devastation. The skeletons of ruined buildings and abandoned entrenchments crumbled in the weather. Many families had moved away. There was hardly a house, barn or church that had not been used as a hospital. Federal troops seemed to delight in using churches as stables and would often burn them when they left. The population of Prince William County dropped by almost half and would not reach its prewar level again for nearly sixty years.

THE ARMY OF NORTHERN VIRGINIA

It may have seemed strange to you that a professing Christian father so freely gave you, a Christian son, to enlist in the volunteer service. My reason was that I regarded this as purely a defensive war. A war in defense of our homes and firesides, of our wives and children. Threatened with invasion and subjugation, it seemed to me that nothing was left us but stern resistance or abject submission.

It began much like every war, the young volunteer marching, the army moving like a great forest of steel, its hundreds of regimental flags giving a russet tinge to the landscape. Filled with thoughts of glory, the young volunteer marched relentlessly onward, the wind rippling the flags and the sunlight sparkling from gun barrels and bayonets.

"You should not," advised his father, "even in the hour of deadly conflict, cherish personal rage against the enemy, any more than the officer of the law hates the victim of the law…War is a tremendous scourge which Providence sometimes uses to chastise proud and wicked nations. There is no occasion, then for adding to the intrinsic evil, animosity to individuals."

The unnumbered host moved steadily forward, finally colliding with the enemy in a shrieking burst of iron upon the plains of Manassas. Glory vanished like a wistful cloud. The columns shuddered, staggered for an instant and then dissolved. During the next four bloody years, the soldiers of the Army of Northern Virginia, daily poised on the brink of death, lost sight of political issues and the false glory that they once thought so important and came to think more passionately of eternal things.

As in every army, drunkenness and vice were abundantly present in the Army of Northern Virginia. Still, it was not uncommon to find soldiers forming around campfires in prayer groups. There was a general demand in the army for small Bibles. When the war broke out, nearly all of the great publishing houses were in the North. "Soldiers are so eager for them that they frequently say they will give several months wages for one," noted one officer. Although the first Confederate Bible was printed in Nashville in 1861, and although the British Bible Society made liberal donations of its publications, religious material was in such scarce supply that many officers lamented, "Our brave boys must beg in vain for Bibles."

One officer who was acutely concerned with the spiritual well-being of his men was General Thomas "Stonewall" Jackson. Jackson made a profession of faith in November 1851 and thereafter energetically took up his new

commitment. He encouraged congregations to send chaplains to the army "who are your best men." Jackson wanted men with a strong commitment, men who would not be put off.

Jackson's strong faith communicated itself to those around him. One officer, lamenting his inability to keep prayer in mind during the normal course of the day, was exhorted to "pray without ceasing." Jackson insisted that it could easily be done:

> *When we take our meals there is grace. When I take a draught of water I always pause, as my palate receives the refreshment, to lift up my heart to God. Whenever I drop a letter in the box at the post-office I send a petition along with it for God's blessing. And so of every other familiar act of the day.*

Many officers and men, impressed by Jackson's general religious character, said, "If that is religion, I must have it."

Most soldiers were not converted by generals but by brother soldiers. A rowdy captain of the Twenty-seventh Georgia Infantry, for example, came out before his comrades and openly embraced religion, to the surprise of all:

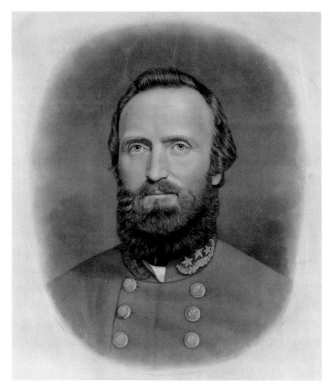

General Thomas Jonathan "Stonewall" Jackson, one of the Confederacy's greatest paladins. *Courtesy of the Library of Congress.*

Men, I have led you into battle, and you have followed me. Alas, I have also led you in all manner of vice, and you have followed me in that too. I am resolved to change my course. I have gone to Christ in simple repentance and faith. I call upon you, my brave boys, to follow me as I shall try to follow the Captain of our Salvation. I want all who are willing to come, here and now, and give me their hands and let me pray for them.

The effect was electric as the men crowded around their beloved captain.

Some professions of faith were, undoubtedly, not permanent but merely produced by the dangers to which the soldiers were exposed. Nevertheless, thousands of men went from apostasy, or from being "silent Christians," to leading prayer and speaking out for Christ. Some, like Sergeant Richard Kirkland, went on to perform dramatic acts of faith and mercy.

On December 13, 1862, Richard Kirkland crouched behind a stone wall overlooking Fredericksburg, pouring deadly fire into advancing Union troops. That evening a thick white fog filled the valley and spread over the battlefield. The only sounds to be heard were the voices of the wounded echoing over the unearthly landscape. A single agonized scream quivered in the darkness and then rose into a crescendo of thousands of pleading voices. Thousands of unattended men lay dying on the frozen field.

All through the night, cries of pain came from the rows of wounded Federal soldiers. Nineteen-year-old Kirkland, a recently professed Christian, wrestled with his conscience. Deeply moved by the anguished cries of his enemies, Kirkland began collecting canteens. His comrades warned him that there could be no flag of truce. Anyone crossing the wall would be shot by the Federals. Despite the warnings, Kirkland took the canteens and scampered over the wall.

Throughout the night, the young sergeant made his way through the writhing mass of mangled bodies. Some begged for a drop of water. Some called on God for pity. Some, with delirious dreamy voices, murmured loved ones' names. Kirkland could do little—relieve a painful posture, give a cool drink to fevered lips, compress a severed artery, apply a rude bandage, take a token or farewell message for some stricken home. Although the acts were small, the intention was great. New hope spread across the stricken field.

Kirkland, who is remembered to history as "the Angel of Marye's Heights," went on to serve at Gettysburg and was killed at the age of twenty at Chickamagua. Kirkland and many thousands of newly found Christians died as the Army of Northern Virginia and the Confederacy went down to final defeat.

THE GILDED AGE

The late nineteenth century in America is often called the Gilded Age. It was an era of unprecedented economic boom, with a few unscrupulous robber barons making enormous fortunes, often unethically and almost always without regard for the public good. Fearing the power of the unscrupulous rich on the one hand and the growing anger of the working class on the other, middle-class reformers, called Progressives, banded together to rein in the robber barons and ameliorate the suffering of the working class. The Progressives advocated a wide range of economic, political, social and moral reforms aimed at public improvement. Starting at the local level and gradually winning state and then national influence, the Progressives laid the foundations of modern American society.

ROBERT PORTNER

The Gilded Age in America was a period of unprecedented economic growth, during which some made staggering fortunes and many went hungry. The very symbol of the booming Gilded Age in Northern Virginia was Robert Portner, a wealthy Alexandria brewer and entrepreneur. Portner arrived in America from Germany in 1853 at the age of sixteen. In 1859, he became a citizen, and he voted for Abraham Lincoln in 1860.

After the Union occupation of Alexandria in 1861, Portner took his tiny life savings and opened a grocery store in Alexandria, selling goods to occupying Union troops. What the troops wanted above all else was alcohol, despite the prohibition of the sale of liquor and beer within city limits. Rowdy troops roamed the streets. Mrs. Robert Jamieson was wounded by a young soldier in a shooting accident. Mary Butler died of a gunshot wound inflicted by a drunken soldier. General John Slough, military governor of Alexandria, recorded:

> *When the present Military Governor took command here, there was…a "reign of terror" in Alexandria. The streets were crowded with intoxicated soldiery; murder was of almost hourly occurrence, and disturbances, robbery, and rioting were constant. The sidewalks and docks were covered with drunken men, women, and children, and quiet citizens were afraid to venture out.*

The two existing breweries increased production, but the army's thirst never slackened, and Portner established Portner & Company in 1862 to meet the need. Soon, Portner rented a schooner to ship beer down the Potomac to thirsty soldiers stationed near Fredericksburg. Between September 1862 and October 1865, the three breweries produced and sold nearly nine thousand barrels of lager beer and ale.

After the war, Portner continued to expand the operations of his brewery, built an ice plant, bought a shipyard, started a construction company, speculated in real estate and established a bank. In 1880, Portner invented an early air-conditioning device that used steam-driven fans to force air over refrigerated pipes. By 1895, the Portner brewery had become so successful that Portner took on investors and formed the National Brewing Company, the largest brewery in the South and a major rival to Anheuser-Busch. The brewery produced twenty-four million pints of beer annually.

In 1897, Portner began building Washington's first luxury apartments at the intersection of Fifteenth and U Streets. The project was dubbed "Portner's Folly" by skeptics, but like other Portner projects this, too, was wildly successful. The luxury apartments rented quickly, and Portner began work on a second wing at Fifteenth and V Streets in 1899.

Robert Portner wasn't all work and no play. He was married with thirteen children. The Portner family spent much of its time on an estate called Annaburg in Manassas. Most of the land was purchased before the mid-1880s. In 1892, Portner built a thirty-five-room mansion and, curiously, a medieval tower on the grounds of the estate. The estate entailed two thousand

acres and had a deer park, a large pond for swans, a smaller pond for ducks, a swimming pool (a very novel innovation for the time) and numerous tenant houses for the estate's staff. Modifying the cooling system he had invented for the brewery, Portner was able to make Annaburg what is believed to be the first air-conditioned house in America. Robert Portner died at Annaburg in 1906, rich, celebrated, loved and surrounded by his family.

Under the heading *"Sic Transit Gloria Mundi"* ("thus passes the glory of the world"), it should be noted that virtually nothing that Portner created now remains. The brewery cut back operations because of Prohibition. The company entered new fields and was rechristened the Robert Portner Corporation. Without Portner's inspiring business genius, however, things did not go well. The brewery buildings in Alexandria were vacant by 1921. The buildings behind the brewery structure were razed in 1932 by order of the fire chief. In 1935, the management of the corporation decided to demolish the main brewery buildings. Two years later, the Robert Portner Corporation was dissolved.

The Annaburg estate passed out of the family's hands and was subdivided for residential and commercial development. The castle tower and outbuildings disappeared over time. In the 1960s, the mansion was incorporated as the central portion of a nursing and rehabilitation complex. The mansion now awaits restoration or demolition. From time to time, an old glass bottle embossed with "Robert Portner Brewing Co." turns up at a flea market.

GOOD ROADS

Roads have been a chronic problem throughout Northern Virginia's history. Early colonists used a network of paths made long before by Indians and wild animals to shape the earliest pattern of roads. From an Indian trail running parallel to the Potomac emerged the Potomac Path, a road along which Dumfries, Colchester and Alexandria developed. Branching from this road at Cameron Run on Hunting Creek was a road, known as "the new Church road," that extended to Falls Church and then on to Winchester. In 1752, the Newgate Road (later known as Braddock's Road) was constructed. Road travel in the eighteenth century was nasty, brutish and slow. Most people preferred to travel by water. Those vehicles, most often slow-moving stagecoaches, that did venture out on the roads were covered with mud or

dust from top to wheel, rattled along uncomfortably, sometimes overturned and frequently sank into bogs.

The Little River Turnpike Company completed a wide turnpike extending west from Alexandria for about thirty-four miles in 1811. This comfortable and well-run toll road operated for nearly a century, and its completion touched off the construction of many turnpikes in Virginia by the time of the Civil War. Notwithstanding these efforts, Robert E. Lee was one of many complaining about Virginia's roads during the 1860s: "It has been raining a great deal… making the roads horrid and embarrassing our operations." Army wagons simply broke down on the road from the mud and rocks.

After the Civil War, the politicians of the Reconstruction period produced much road legislation. Unfortunately, most of it was meaningless. One law made it illegal to drive or lead a bear on a public highway and another set a fine of five dollars for a pedestrian who crossed a bridge at a pace greater than a walk. Twenty-five years after the war, Virginia's roads were far worse than when the war began.

Good roads were one of the priorities of the Progressive era. "Good Roads" societies were organized throughout Virginia as early as 1894. Local meetings and statewide conventions were held, and enthusiasm grew swiftly. The enthusiasm came just in time. In September 1895, the Duryea brothers established the first American company to manufacture gasoline-driven cars: the Duryea Motor Wagon Company. In 1904, the Ford Motor Company produced 1,695 cars, and by 1907 it had increased production to 14,887. What is believed to have been the first automobile of any kind to be operated in Virginia was driven along Norfolk streets in 1899, powered by kerosene. By 1910, Virginians owned 2,705 motorcars. Virginia's love affair with the automobile had begun in earnest and has never stopped, as demonstrated by the fact that the number of registered cars in Virginia doubled in twenty-five years from 3.5 million in 1980 to almost 7.5 million in 2005. There is now a car for virtually every man, woman and child in the commonwealth of Virginia. Most Northern Virginians probably think these 7 million cars are, in fact, in Northern Virginia. Before bemoaning their own traffic woes, however, drivers may wish to consider the automobile experiences of President William Howard Taft in 1911.

On July 21, 1911, President Taft was scheduled to address a group of Union and Confederate veterans in Manassas at the Jubilee of Peace, celebrating national reconciliation on the fiftieth anniversary of the First Battle of Manassas. At the suggestion of his military aide, Major Archibald Butt, the president decided to motor to Manassas rather than take the train.

Numerous congressmen bent on making political points with the visiting veterans accompanied the president. The presidential party, due in Manassas at four o'clock, set out from the White House in four motorcars at half past twelve. About five miles from the town of Fairfax, clouds began to gather, and the caravan picked up speed to reach the town before the storm broke. The storm was short and sharp—a regular cloudburst.

The president had lunch in Fairfax and then set out again for Manassas before three o'clock. According to Major Butt, "[We] were bumped and jolted over the worst road I have ever seen" before coming to a motorcar stranded in a stream filled with frantic people. It was part of the presidential party, a car filled with senators. Major Butt waded into the stream and found the lowest point. The rest of the cars proceeded to ford the stream, laughing at the stranded senators as they passed. The laughter was short-lived. The party soon reached Little Rocky Creek, a stream even more treacherous than the first. Another car was put out of commission. The two remaining cars retraced their bumpy route and recrossed the first stream trying to make a detour that locals said would take the president into Manassas. As the party recrossed the first stream, yet another car stuck fast in the water. From here the trip was uneventful, except twice horses were frightened on the road. Just after passing Centreville, the president's car ran into dust, for between there and Manassas not a drop of rain had fallen. At the edge of town, the president's car was met by a troop of cavalry, and through clouds of dust the president was escorted into town.

According to Major Butt, once at the Jubilee of Peace the president gave

> *a flubdub speech about the Blue and Gray which brought tears to the eyes of the veterans of both sides and smiles to the faces of politicians. Every politician has a canned speech up his sleeve for these reunions, and while they all smile while someone else makes them, yet they take themselves most seriously when making them themselves.*

While the president gave his speech, two members of his staff scurried about trying to see what could be done about getting back to Washington by train. They succeeded in finding a railroad magnate with a private railway car, which he put at the disposal of the president. When the president arrived at the little depot at seven o'clock, there was gathered most of the party that had set out from Washington, bedraggled, wet and thirsty. They had arrived in carts, buggies and "any old vehicle which they could hire along the road." The solicitor general never showed up at all.

EDUCATION

During the late nineteenth century, Virginia devoted little attention to funding public education. Northern Virginia was no different. In 1886, for example, there were seventy-three schools operating in Fairfax County, of which sixty-four had no toilet facilities of any kind. Only six of the schools had more than one room. Only 35 percent of the county's school-age population attended school. The problems Progressives sought to remedy were many. Virginia spent only about a quarter of the national average on public education and had no mandatory attendance law. Access to four-year high schools was severely limited, leaving most students in the state with only a grade school education. In 1900, almost a quarter of Virginia's population was illiterate. Women were the first to call for improvements to Virginia's educational system. An outpouring of public support led the Virginia General Assembly to double the state's education budget. Despite the efforts of reformers, by 1920 Virginia was spending only about half the national average on public education.

The problem for African Americans was even worse. Virginia legally segregated its public schools from their inception in 1870. In 1896, the United States Supreme Court ruled that public schools should be separate but equal. In 1918, there were only four black high schools in the entire state. White schools generally received about four times the funds allocated to black schools, and the white schools were pitiful; one teacher complained that the only materials provided to her by Fairfax County were "a broom and a box of chalk."

Amid this generally dismal scene of neglect, two bright examples of progress stand out: the Manassas Industrial School and Ivakota Farm.

Jennie Dean (1852–1913) was born into slavery. After only a few months at a primitive country school, she entered domestic service in Washington. Each week she saved her meager wages until she paid off her father's debts and saved enough for her younger sister to get enough education to become a teacher. Jennie Dean was a remarkable woman. Economy, efficiency and education became her watchwords. Alarmed by the exodus of young blacks to the cities where work was scarce, living conditions were miserable and vice was rampant, she warned parents, "Keep your children at home. Don't send them to the cities. You must buy your lands; become taxpayers."

Jennie Dean followed her dream of education for African American children, relentlessly pursuing white and black benefactors. She told the

congregation of one church, "You can give something if it be only a day's labor." Oswald G. Villard summed up the impact she had on people:

> *I think it was her own straightforward honesty and refusal to pretend to be anything else than what she was, a plain woman, unashamed of being a cook who made money to help the School and her people that impressed me...She was just a plain, simple, dignified black woman with no gift for oratory and no charm beyond what I have said...her straightforwardness and sincerity.*

Jennie Dean's goal was "to educate the head, the heart and the hand." It was this philosophy that led to the founding of the Manassas Industrial School for Colored Youth in 1894. African American pupils received academic instruction, as well as being trained in a trade such as carpentry, masonry, machinery or agriculture. Parents, sometimes with the help of relatives and friends, paid tuition and provided transportation. Donors helped support the school as well, but it always struggled financially. The school eventually educated over 6,500 students on a one-hundred-acre campus. Contemporaries of Jennie Dean said of her, "She taught that life is a privilege as well as a responsibility and that birth or origin have but little bearing on success or failure if the will to help one's self is cultivated and encouraged."

Another inspirational educational enterprise began during the Progressive era. In 1915, Clifton resident Ella Shaw donated her two-hundred-plus-acre farm to the National Florence Crittenton Mission. Named for the states where she had lived—Iowa, Virginia and North Dakota—Ivakota provided a rural setting for inspirational, physical, domestic and religious education primarily for delinquent girls.

Social reformer Dr. Kate Waller Barrett of Alexandria oversaw the program. Ivakota included a school, nursery, health clinic, dormitories and a commercial farm. At Ivakota, all of the girls learned domestic skills such as gardening and canning, received a formal education and enjoyed basketball, baseball, music and friendships. Local children attended classes at the farm, and community interaction was encouraged. Most of the young women living at Ivakota went on to embody Dr. Kate Waller Barrett's slogan for the school: "I am an American girl and I am going to make the world know that I am worth something."

WORLD WAR I THROUGH THE
GREAT DEPRESSION

By the turn of the twentieth century, America's population and economy were expanding at a tremendous rate. America was on the verge of becoming a world power. In 1898, war with Spain brought vast new Pacific domains under American control. In 1908, President Theodore Roosevelt sent a U.S. Navy battle fleet, popularly known as the Great White Fleet, around the world on a goodwill mission, which also served to demonstrate the country's growing military power. This power was soon to be tested as the nation entered World War I in 1917.

In 1918, at the conclusion of the world war, the pace of change seemed to go into hyper-drive. Women got the vote. Styles became daring. New technology was everywhere. The national imposition of prohibition on the sale of alcohol in 1920 only seemed to accelerate the momentum for change as America entered the Roaring Twenties. Fortunes were made in the stock market, illegal booze flowed freely and it seemed the good times would never end. They did. On October 29, 1929, Black Tuesday, the stock market crashed, issuing in the Great Depression, which would last for some ten years, bringing economic hardship to millions.

WORLD WAR I AND THE MILITARY

Two of Northern Virginia's largest and most enduring military facilities, Fort Belvoir and Quantico Marine Corps Base, were born as a result of America's entry into World War I.

By the late nineteenth century, Belvoir—the stately estate of George William Fairfax, an old and dear friend of George Washington and husband of Washington's purported secret love, Sally Fairfax—lay in ruins. One visitor to the site, just south of Mount Vernon on the bluffs above the Potomac River, wrote, "All was a tangle of brushwood and fallen trees; but such an enchanting view over the river! There were some heaps of bricks, and a poor old fig tree in the clearing, which I suppose, was once the garden."

The federal government acquired the Belvoir Peninsula in 1910 with plans to develop the area into a reformatory. Local citizens banded together with patriotic organizations such as the Daughters of the American Revolution and the Mount Vernon Ladies' Association in opposing the establishment of a reformatory so close to Mount Vernon. The reformatory idea was scrapped, and Congress transferred the property to the War Department in 1912, following a request by the U.S. Army's Engineer School to use the area as a training site. The Army's Engineer School, located in Washington, needed field training areas and rifle ranges. The Belvoir Peninsula provided challenging terrain where soldiers could build pontoon bridges and conduct rifle practice.

America entered World War I in April 1917. In January 1918, Camp A.A. Humphreys, named after Union Civil War general and former chief of engineer corps Andrew A. Humphreys, was established on the Belvoir Peninsula. Within only four months of the start of construction, Camp A.A. Humphreys was in operation. Over the course of eleven months, extensive camp facilities were constructed, with most of the heavy labor being done by segregated African American service battalions. To accommodate the twenty thousand troops that were to use the camp, 790 temporary wood-frame buildings were constructed. A newly constructed dam across Accotink Creek and a water filtration plant ensured a steady flow of fresh water. Transportation systems and utilities were also improved. The unpaved Washington-Richmond Highway was surfaced in concrete within six months, and a plank road was built linking the camp to the highway. Standard-gauge and narrow-gauge railways followed. Building these transportation systems facilitated

Camp A.A. Humphreys in World War I. Later, the camp was renamed Fort Belvoir. *Courtesy of the Library of Congress.*

deliveries to the camp and provided engineer training experience for troops being sent to Europe. During 1918, some sixty thousand troops received training in engineering, trench warfare and gas warfare. After the war, Camp A.A. Humphreys became a permanent installation and was renamed Fort Belvoir in the 1930s.

Down the river, in Prince William County, another major military installation was taking shape. Told to expand its training capabilities, the U.S. Marine Corps began inspecting promising sites in the spring of 1917. Some five thousand acres along Quantico Creek were leased from an ailing development company that had been promoting the area for recreation. There was an officially incorporated town, a shipyard and a small hotel that had been built to attract tourists. The area was largely uninhabited. The first U.S. Marine contingent to arrive consisted of ninety-one enlisted men and four officers. Soon, thousands of U.S. Marines would come pouring in for training. There were not enough barracks, and the troops did their laundry in the river. Troops unaccustomed to a Virginia summer complained, "Quantico was hotter than a pistol and muddier than a pigsty."

An airplane factory in Alexandria in 1918. *Courtesy of the Library of Congress.*

Aviation first arrived at Quantico in July 1918, when two kite balloons were flown to spot artillery fire. Soon, four seaplanes were assigned to Quantico. Naval aviation actually began in 1911, only six years after the Wright brothers' first successful flight, with a congressional appropriation of $25,000. This money went for the purchase of three aircraft, one from the Wright brothers themselves. The first U.S. Marine aviator (he was the fifth naval aviator) was First Lieutenant Alfred A. Cunningham. On December 7, 1917, the U.S. Marine aviators were ordered overseas to fight in France and to take part in antisubmarine warfare. In 1919, a flying field was laid out at Quantico and land was leased to accommodate a squadron returning from combat in Europe. The facility was later named Brown Field, in memory of Second Lieutenant Walter V. Brown, who lost his life in an early accident at that location.

By 1920, Quantico Marine Corps Base had become a permanent fixture in Northern Virginia, as U.S. Marine Corps schools were founded and the corps embarked on the mission to "make this post and the whole Marine Corps a great university."

SUFFRAGISTS

At the intersection of Lorton Road (Local Route 642) and Ox Road (Virginia Route 123), a history marker notes:

> *In the nearby Occoquan Workhouse, from June to December, 1917, scores of women suffragists were imprisoned by the District of Columbia for picketing the White House demanding their right to vote. Their courage and dedication during harsh treatment aroused the nation to hasten the passage and ratification of the 19th Amendment in 1920. The struggle for woman's suffrage had taken 72 years.*

Behind these bland words lurks a dramatic story.

The national women's suffrage movement began in 1848 and had gained a substantial following by 1916. With the approach of the First World War, many of the activists in the National American Woman Suffrage Association turned to either pacifism or to support for American preparedness. The more radical National Woman's Party, created by Alice Paul and Lucy Burns in 1916, continued to focus on winning the vote for women. Lucy Burns and Alice Paul were activists, suffragists and good friends. Lucy Burns attended Vassar College and Yale University, and Alice Paul attended Swarthmore College and earned her PhD from the University of Pennsylvania. They were despised by men and opposed by conservative women.

The National Woman's Party felt betrayed by Woodrow Wilson. The women believed that Woodrow Wilson had made a commitment to support a suffrage amendment in his campaign for a second presidential term. When, after his second inauguration in 1917, Wilson did not fulfill this promise, Paul organized picketing of the White House. This was unprecedented. Never before had anyone protested in front of the White House. Some considered the action nothing short of treason. A woman in New York wrote a letter to the editor of the *New York Times* calling picketing of the White House "a menace to the life of the President—a silent invitation to the assassin." Undeterred, suffragist demonstrators carried banners quoting Wilson's own speeches: "We shall fight for the things which we have always carried nearest our hearts—for democracy, for the right of those who submit to authority to have a voice in their own governments."

On June 22, 1917, police arrested two protestors on charges of obstructing traffic. These charges were dropped. One June 25, twelve women were

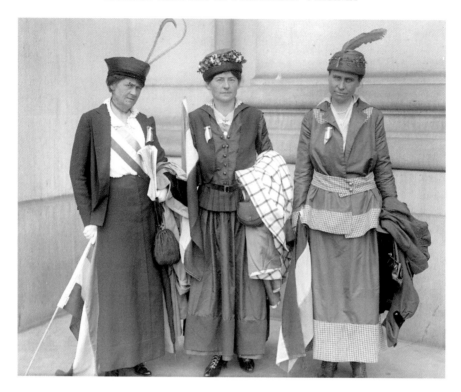

Suffragists demanding the right to vote for women. *Courtesy of the Library of Congress.*

arrested for obstructing traffic and sentenced to three days in jail or a twenty-five-dollar fine. The women chose jail. On July 14, sixteen women were arrested and sentenced to sixty days in jail or a twenty-five-dollar fine. Again, the women chose jail. After they had served three days, President Wilson pardoned the women. As the summer wore on, an increasing number of women were arrested and the jail terms lengthened. Finally, on October 20, 1917, Alice Paul was arrested and sentenced to seven months in prison. Paul and many others were sent to the Occoquan Workhouse.

In 1910, the U.S. government acquired land along the Occoquan River. This site became the Occoquan Workhouse, designed first as a workhouse and later as a reformatory for the District of Columbia. The workhouse was first used as a small prison in 1916, housing 60 male inmates. The prison facilities quickly grew, and in 1917, the workhouse received its most famous inmates: the suffragists. In all, some 170 suffragists were incarcerated at the Occoquan Workhouse.

The new inmates were middle-class and upper-middle-class women. Among those arrested were university graduates, students, teachers,

nurses, at least two physicians, a geologist and a professor of history. The socially prominent included the niece of a former vice president of the United States. The youngest suffragist inmate was nineteen, and the oldest to serve at Occoquan was seventy-three. The unlettered male guards were not accustomed to such prisoners. A class and gender fuse had been lit.

The women were treated like common criminals. The detainees had their clothes taken from them and were given coarse prison clothing to wear. The women were ordered to perform prison work. Their food was the usual worm-infested and contaminated food given to male prisoners. Protesting the poor treatment and general state of prison conditions, the women insisted they were political prisoners, not criminals, and should be treated accordingly. The guards were dumbfounded.

Led by Alice Paul and Lucy Burns, some of the women refused to work. They were put in solitary confinement, fed bread and water and forced to scrub floors. Alice Paul, Lucy Burns and others went on a hunger strike. Harried prison doctors placed Paul in a psychiatric ward and threatened to transfer her to an insane asylum. The hunger strike persisted. Afraid that Paul might die, prison officials started force feeding. Three times a day for three weeks, a tube was forced down Alice Paul's throat, and liquids (primarily consisting of raw eggs and milk) were poured into her stomach. Lucy Burns had a similar experience. Burns refused to open her mouth, and the feeding tube was shoved up her nostril.

Things came to a head on the night of November 15, 1917, when frustrated guards went on a rampage. Guards beat Lucy Burns, chained her hands to the cell bars above her head and left her there for the night. Another detainee, Dora Lewis, was hurled into a dark cell, where she hit her head against an iron bed, knocking her out. Her cellmate, who believed Mrs. Lewis to be dead, suffered a heart attack. According to affidavits, other women were grabbed, dragged, beaten, choked, slammed, pinched, twisted and kicked.

As husbands and family members carried stories about how the detainees were being treated to the newspapers, public indignation grew, to the great embarrassment of the Wilson administration. On November 27 and 28, 1917, all of the protesters were released. In March 1918, the D.C. Circuit Court of Appeals declared all of the suffragist arrests, trials and punishments to be unconstitutional.

On January 9, 1918, President Wilson announced support for a constitutional amendment to allow women's suffrage. To keep up the

pressure, suffragist protestors resumed picketing the White House. Paul urged men to vote against anti-suffrage congressmen in the November 1918 elections. After the election, most reelected members of Congress were pro-suffrage. Approved by the House of Representatives and the Senate, and ratified by the requisite thirty-six states, the Nineteenth Amendment to the United States Constitution, which prohibits denying any citizen the right to vote because of that citizen's sex, was ratified on August 18, 1920.

PROHIBITION

The campaign to outlaw the sale of alcohol was one of the most controversial and divisive reforms of the Progressive era. On January 29, 1919, the Eighteenth Amendment to the United States Constitution was ratified, and one year later, on January 17, 1920, in accordance with the provisions of implementing the law, America went dry. Or did it?

Virginia had been wrestling with the prohibition problem for decades before the national government stepped into the fray. The anti-drink campaign began in the 1880s, when church women organized local chapters of the Woman's Christian Temperance Union (WCTU). The anti-drinking activists argued that saloons corrupted boys, led to spousal abuse and threatened the family. The efforts of the WCTU eventually led the General Assembly to endorse a "local option" law in 1886, which gave local governments the option of holding elections on prohibition in their jurisdictions. Rural evangelical Christians strongly favored outlawing alcohol, while people living in cities were pro-choice. By 1900, much of rural and small-town Virginia had voted to outlaw alcohol sales. In 1903, anti-drink activists convinced the General Assembly to pass the Mann Bill, which prohibited the sale of alcohol in areas without police protection, further reducing rural access to alcohol. The following year, the General Assembly ordered all saloons closed on Sundays. By 1910, most of Virginia's counties had voted to impose prohibition; 75 percent of Virginia's saloons had been closed between 1901 and 1910.

Northern Virginia was ambivalent. Alexandria was home to the large Robert Portner brewery and time after time voted against prohibition. Towns like Manassas vacillated. They would vote prohibition in and then

they would vote it out. Saloons would be closed for a year or two and then they would reopen. By the end of 1913, 95 percent of the state was dry. Most city dwellers rejected prohibition in local option elections. Getting the issue of alcohol on a statewide ballot became the focus of the anti-drink forces. In 1913, the General Assembly approved an "enabling bill," which sent the issue to a statewide vote on September 22, 1914. Two-thirds of voters approved the measure, and on November 1, 1916, statewide prohibition went into effect, almost three years before Prohibition was adopted nationally by constitutional amendment.

Enforcement became the central problem. Many people wanted alcohol, and many people wanted to provide the people with what they wanted. The Chesapeake Bay, with its many small bays and inlets, was ideal for smuggling. Additionally, Virginia had a long-standing tradition of moonshining. Moonshiners were delighted to find that Prohibition furnished a large market for their product. Many Northern Virginians began to keep bottles of "white lightning." It was colorless, it looked like water and it was often one hundred proof. High school boys, disregarding the law, went out into the woods, met moonshiners and brought a pint of moonshine to their school dances. More staid citizens were able to get a prescription from the family doctor for a bottle of liquor. Local drugstores stocked pints of scotch and bourbon for medicinal use.

An account of the period by a Manassas man captures the spirit of the times:

> *Traveling on some of the side roads…could be very dangerous since bootleggers did not desire to be caught by surprise by law enforcement officials. One Sunday evening my father was taking us to a friend's home on Route 234 about two miles south of Manassas…when suddenly a car came from a side road and sounded like it was back-firing, but my father knew it was gun shots rather than back-firing, so he stopped and the Model-T Ford pulled alongside and out stepped the constable, pistol in hand pointing at us. It was soon obvious that the constable had been drinking…The constable was a good friend of my father's and tried to explain that he was looking for bootleggers.*

By 1932, Virginia, along with most of the rest of the country, was ready to repeal Prohibition. The promised benefits, such as the elimination of crime, never emerged. In fact, things got worse as the growth of organized criminal gangs produced just the opposite result. In the 1932 presidential election,

Virginia voted overwhelmingly for Franklin Roosevelt, who promised to end Prohibition. Overturned at the national level by the Twenty-first Amendment to the U.S. Constitution, prohibition in Virginia as a state was finally voted out by a special election in 1933. On March 7, 1934, the Virginia Department of Alcoholic Beverage Control was established and has regulated the sale of alcohol ever since.

ART AND THE GREAT DEPRESSION

During the Great Depression of the 1930s, the federal government set up a number of public works programs to provide work for all Americans. One of these programs involved artists. Harry Hopkins, President Roosevelt's relief administrator, said in response to criticism of federal support for the arts, "[Artists] have got to eat just like other people." The Section of Fine Arts was established in 1934 and was administered by the Procurement Division of the Treasury Department. The section's main function was to select high-quality art to decorate public buildings. One percent of the funds allocated for the construction of public buildings was set aside for "embellishments." Artists were paid from these funds. By providing decoration in public buildings, art was made accessible to all people.

Post offices were considered a prime building objective of the Roosevelt New Deal and a prime place for the display of public art. Large murals, depicting enduring images of the "American scene," were the artistic vehicle of choice. Artists were chosen in open competitions to paint scenes reflecting America's history and way of life on post office walls large and small. Mural artists were provided with guidelines and themes. Scenes of local interest and events were deemed to be the most suitable. Americans shown at work or at leisure grace the walls of the New Deal post offices. Social realism painting, though popular at the time, was discouraged. You will not see bread lines or labor strikes depicted in New Deal public art. The heroic was to be celebrated and embraced. Historical events depicting courageous acts were popular themes for post office murals.

Seven of these New Deal artistic gems still exist in Northern Virginia. In 1940, Auriel Bessemer completed seven murals for Arlington County's first public building, the Joseph L. Fisher Post Office in Clarendon. Bessemer was

paid $800 to paint the seven murals depicting familiar local scenes such as Great Falls and Roosevelt Island.

Painters working for the New Deal were not the only artists grappling with the problems of the Depression. In the 1930s, architect Frank Lloyd Wright grappled with the problem of creating a moderately priced house that was both aesthetically pleasing and environmentally friendly. Wright, who had been primarily employed to design houses for millionaires, began designing so called "Usonian" houses for the common man—houses that were simple, functional and beautiful. Wright believed that the Usonian house would represent a new form of truly American architecture.

The Pope-Leighey House, now on the grounds of Woodlawn Plantation in Fairfax County, is a classic example of this type of architecture. The house was commissioned by journalist Loren Pope in 1939 and was originally located in Falls Church. The 1,200-square-foot house features native materials, a flat roof and large cantilevered overhangs for passive solar heating and natural cooling. A strong visual connection between the interior and exterior spaces is emphasized. Wright designed the house, along with his other works, to bring nature inside. Wright's innovative use of four native materials (wood, brick, glass and concrete) created a sense of spaciousness. The interior of the house is set up to be an efficient living space. The interior features many types of versatile built-in furniture.

Despite its beauty, the house has certain drawbacks. There is, for example, very little room for storage. Wright believed that you should only keep things that you used often. As a result, closets are small and there is no room for clutter. Owning a house designed by Frank Lloyd Wright (recognized by the American Institute of Architects in 1991 as "the greatest American architect of all time") was not just a purchase but a commitment to a way of life. Although Wright always created works of art, some of the practical details of daily living sometimes suffered.

In 1946, Loren Pope sold the house to Robert and Marjorie Leighey. In 1961, the State of Virginia condemned the house to make way for Interstate 66. Robert Leighey died in 1963, shortly before the state issued an order to vacate the premises. Marjorie Leighey donated the house to the National Trust for Historic Preservation, which moved the house to the grounds of Woodlawn Plantation (9000 Richmond Highway).

Another Wright masterpiece (still in private hands) was built in McLean in 1959. Luis Marden was a photographer for *National Geographic* who led a colorful and eclectic life. He and his wife, Ethel, were the perfect couple

to live in a Wright house. Although the floors cracked and the furnace was never properly installed, Mrs. Marden wrote to Wright in 1959:

> *Our beautiful house…stands proudly just under the brow of the hill, looking down always on the rushing water which constantly sings to it, day and night, winter and summer. It will…represent for us, as you put it when you were here, "a way of life."*

World War II through the Cold War

"There is a mysterious cycle in human events. To some generations much is given. Of other generations much is expected. This generation of Americans has a rendezvous with destiny." So said President Franklin D. Roosevelt in words that epitomize the nearly twenty years of crisis and trial that faced what has become known as "the Greatest Generation."

In the 1940s, Americans just emerging from the trials of the Great Depression were called upon to turn back Nazi aggression in Europe and Japanese militarism in Asia. After four long years of sacrifice, and the loss of 300,000 soldiers, America was not long permitted to enjoy the blessings of peace. A new prolonged struggle with international communism started at the moment the guns of the Second World War fell silent. A generation would grow to adulthood under the shadow of global thermonuclear war.

The Pentagon and Its Predecessor

Seeing the massive Pentagon today, few people realize it had a predecessor. Fort Runyon, built in the early days of the Civil War as part of the Union army's defense of Washington, was approximately the same size and shape and was located in almost the same spot as the modern-day

Pentagon, built some eighty years later. The fort was constructed of timber and earthworks and guarded the approaches to the Long Bridge leading into Washington.

Because of the importance of the Long Bridge, which linked Virginia directly with downtown Washington, Fort Runyon was designed to be the largest fort in the entire system of defenses protecting Washington. The perimeter (some 1,500 yards) was guarded by twenty-one guns and garrisoned by two thousand troops. The fort was built directly at the crossroads of two turnpikes and served as a checkpoint for vehicles entering the city via the Long Bridge.

After the war, the fort was abandoned and taken over by squatters, most of whom were freed ex-slaves. The wood and timber that made up the fort was burned by squatters or scavenged for building materials in the first few years after the war, but the fort's embankments and trenches lasted much longer. A 1901 tour guide of Washington instructed tourists to look out of the windows of their train at the south end of the Long Bridge to catch a glimpse of the decaying fort, "erected in 1861 to guard the head of the bridge from raiders." Two years later, a new railroad bridge was constructed, replacing the old Long Bridge. In 1906, a highway bridge was constructed nearby. Together, these two projects destroyed what little remained of Fort Runyon. The approach routes to the bridges ran directly through the fort's earthworks. By the 1930s, all traces of Fort Runyon had vanished. (Exit 9 on Interstate 95 is now at the approximate center of the old fort.)

As the last traces of Fort Runyon vanished, the military was set to build a new pentagonal installation in Northern Virginia.

In the 1930s, the War Department was scattered throughout dozens of buildings in Virginia, Maryland and the District. In May 1941, the secretary of war told the president that the department needed a central location. Congress authorized a new headquarters for the War Department, and plans were drawn up. Arlington Farms, between Arlington National Cemetery and Memorial Bridge, was selected as the site. The building was designed to conform to the dimensions and terrain of the site. In short, it was designed to be a pentagon to fit the space.

When presented with the plan, President Roosevelt liked the design but hated the site, which would have impaired the view of Washington from Arlington National Cemetery. Consequently, the design remained but a new site was found. Ground was broken on September 11, 1941, less than three months prior to America's entry into World War II. The building was officially dedicated and ready for occupancy on January 15, 1943. The

design and construction of a building this size would normally have taken at least four years.

Minimizing the use of steel because of the exigencies of World War II, the Pentagon was built as a reinforced concrete structure, using 680,000 tons of sand dredged from the Potomac River. Whenever possible, army engineers avoided using scarce war materials. For example, concrete ramps and stairways were used instead of passenger elevators, and concrete drainpipes were used rather than metal pipes. Bronzer doors, copper ornaments, metal toilet partitions and other unnecessary ornamentations were eliminated.

The Pentagon is the world's largest office building by floor area, housing some twenty-six thousand military and civilian employees. The building has five sides, five floors above ground and five ring corridors per floor, with a total of 17.5 miles of corridors. It covers twenty-six acres.

Exactly sixty years after the groundbreaking ceremony, the September 11, 2001 terrorist attacks occurred. Hijacked American Airlines Flight 77 crashed into the west side of the Pentagon, killing almost two hundred people both onboard the plane and inside the building. The plane penetrated three of the Pentagon's five rings. The task of rebuilding the damaged section of the Pentagon was given the name the "Phoenix Project" and set a goal of having the outermost offices in the damaged section occupied again by September 11, 2002. The first Pentagon tenants whose offices had been damaged during the attack began moving back in on August 15, 2002, nearly a month ahead of schedule.

"PO Box 1142": The Top-Secret POW Camp

John Gunther Dean, a young American soldier whose Jewish family had fled Germany in the late 1930s, was summoned to the Pentagon, where an army officer asked him if he knew how to speak German. "Yeah, I speak German like a native," said Dean.

Dean was handed a nickel and a phone number and then mysteriously dropped off in the middle of Alexandria. Dean went into a drugstore and dialed the number. A voice on the other end said, "Dean, you stay outside and we'll pick you up in a staff car." Minutes later, he was being driven south toward Mount Vernon, ending up at Fort Hunt on the banks of the Potomac.

Fort Hunt, a sprawling military base supporting shore batteries on the river, was built in 1897 just prior to the Spanish-American War. In the 1930s, the now-defunct fort was turned over to the National Park Service. With the outbreak of World War II, Fort Hunt was transferred back to the military "for the duration." The fort was turned into a top-secret intelligence facility used for the interrogation of German prisoners of war and captured German scientists.

Known only by its secret code name, "PO Box 1142," throughout the war, Fort Hunt mushroomed into a substantial installation with 150 new buildings surrounded by guard towers and multiple electric fences. The intelligence operations being carried out were so secret that even building plans were labeled "Officers' School" to throw curious workmen off the scent. Nearby residents watched unmarked, windowless buses roar toward the fort day and night.

The Military Intelligence Service (MIS) had two special operations units working at Fort Hunt known as MIS-X and MIS-Y, one charged with interrogating high-level German prisoners of war and the other devising ways of communicating with and assisting the escape of American POWs held by the Nazis.

At first, prisoners were mostly U-boat crew members who had survived the sinking of their submarines in the Atlantic Ocean. As the war progressed, PO Box 1142 shifted its attention to some of the most prominent scientists in Germany, many of whom surrendered and gave up information willingly, hoping to be allowed to stay in the United States. Germany had superior technology, particularly in rocketry and submarines, and the information obtained at Fort Hunt was critical to the security of the United States as it moved into the Cold War and the space age. Nearly four thousand German POWs spent some time in the camp's one hundred barracks. Among the prisoners were such notables as German scientist Wernher von Braun, who would become one of America's leading space experts; Reinhard Gehlen, a Nazi spymaster who would later work for the CIA during the Cold War; and Heinz Schlicke, the inventor of infrared detection.

One of the reasons for secrecy was the fact that the interrogation operations at Fort Hunt were not strictly in accordance with the Geneva Code Conventions. The whereabouts of the German POWs were not immediately reported to the International Red Cross as required. Prisoners from whom military intelligence thought it could obtain valuable information, particularly submarine crews, were transferred to Fort Hunt

immediately after their capture. There they were held incommunicado and questioned until they either volunteered what they knew or convinced the Americans that they were not going to talk. Only then were they transferred to a regular POW camp and the International Red Cross notified of their capture.

Although the mere existence of this unit and its intent violated the Geneva Convention on POW treatment, extracting information was done without torture, intimidation or cruelty. The average stay for a prisoner at Fort Hunt was three months, during which time he was questioned several times a day. Interrogating officers soon found that they learned more from bugging the conversations of their prisoners than they did from formal interrogation sessions. Many prisoners spoke freely with one another, providing American intelligence officers with much valuable information on war crimes, the technical workings of U-boats and the state of enemy morale. Even rocks and trees were bugged, and the location of prisoners was carefully monitored throughout the day to allow the correlation of taped conversations with particular prisoners.

Almost all of the American interrogators were Jewish immigrants from Germany, some of whom had lost entire families in the Holocaust. They were recruited to PO Box 1142 for their language skills and, in the cases of Fred Michel and H. George Mandel, for their scientific backgrounds. Any anger toward their captives had to be suppressed. Some found it difficult to watch German officers having a dunk in the camp pool as a reward for cooperation.

Only one POW was shot trying to escape. Lieutenant Commander Werner Henke, the highest-ranking German officer to be shot while in American captivity during World War II, was killed while attempting an escape from Fort Hunt in 1944. Henke, the commander of the German submarine *U-515*, was captured with forty of his crew on April 9, 1944, when his U-boat was sunk. The British press had earlier labeled Henke "War Criminal No. 1" for machine-gunning survivors of the passenger ship SS *Ceramic*, which *U-515* sank on December 7, 1942. When interrogators threatened to turn Henke over to the British to face war crime charges unless he cooperated, Henke attempted an escape and was shot.

PO Box 1142 also provided support to captured American POWs in German hands. Packages, purportedly from loved ones, contained baseballs, playing cards, pipes and cribbage boards. Crafted at Fort Hunt, these innocuous items cleverly hid compasses, saws, escape maps, wire cutters and other such items.

After the war, Fort Hunt was returned to the National Park Service, which continued to develop the site as a recreational area. All of the buildings connected with the interrogation center were demolished. Not a single trace of the top-secret facility remains, except a commemorative plaque near the flagpole that honors the veterans of PO Box 1142 and their invaluable service to their country.

WORLD WAR II IN NOVA

World War II brought sweeping changes to Northern Virginia, as it did to communities throughout America. Thousands of men enlisted or were drafted into the military. Large numbers of women, many of whom had never before worked outside the home, took full-time jobs to help meet labor shortages. Unlike subsequent wars that America engaged in, World War II was a "total war" in which sacrifices were required on the homefront. Americans were told to "use it up, wear it out, make do, or do without."

Many foods and war-related items were rationed. Rationing began in January 1942. Tires were the first item to be rationed because the Japanese had cut supplies of natural rubber. By November 1943, automobiles, sugar, gasoline, bicycles, footwear, fuel oil, coffee, stoves, shoes, meat, lard, shortening and oils, cheese, butter, margarine, processed foods (canned, bottled and frozen), dried fruits, canned milk, firewood and coal, jams, jellies and fruit butter were all being rationed. Each person received a ration book, including small children and babies who qualified for canned milk not available to others.

In the beginning of the war, gasoline shortages were acute in Virginia. Most petroleum was shipped by sea, and German submarines prowled off the East Coast. Naval warfare raged off the coast of Virginia in 1942. German submarine "wolf packs" sank eight ships off the Virginia–North Carolina coast in January 1942, eight more in February and one a day in March 1942. An "A" sticker on a car was the lowest priority of gas rationing and entitled the owner of a car to four gallons of gas per week. "B" stickers were issued to defense industry workers, entitling them to up to eight gallons of gas per week. "C" stickers went to workers essential to the war effort, such as doctors. "T" rations were for truckers. "X" stickers, the highest priority

in the system, entitling the holder to unlimited gallons of gasoline, were reserved for police, firemen and the clergy.

Young and old were exhorted to conserve, share and recycle to help win the war. In Home Demonstration Clubs, women learned about growing victory gardens, preserving food and caring for clothing. Buying government bonds helped pay for the war effort, and children contributed by buying war stamps at school. Schools conducted drives to collect scrap metal, rubber, wastepaper, cooking fats and tin cans.

Patriotic volunteers poured into public service by the thousands. Civil defense activities relied on volunteers to watch the skies against aerial attack, run air raid drills and administer nighttime blackout policies. An air defense watchtower in Burke and a facility on the grounds of Annandale United Methodist Church were part of the facilities defending the nation's capital. All lighting had to be extinguished to avoid helping the enemy in targeting at night. Only later did it become clear that Northern Virginia was in no danger of air attack. Although the Germans had the desire to bomb America (German armaments minister Albert Speer later confessed, "In a kind of delirium [Hitler] pictured for himself and for us the destruction of New York in a hurricane of fire. He described the skyscrapers being turned into gigantic burning torches, collapsing upon one another, the glow of the exploding city illuminating the dark sky."), in fact, enemy bombers could not cross the oceans. The air watch continued until the end of the war, the main purpose being to remind people that there was a war on and to provide activities that would engage the civil spirit of millions of people not otherwise involved in the war effort.

The war years influenced the aspirations of women and blacks. Although only 10 percent of women workers were in war industry jobs in 1944, the war opened up new fields to women who took on jobs previously done by men throughout the economy. The aspirations of African Americans were similarly raised. African American leaders told white audiences, "Help us get some of the blessings of democracy here at home before you jump on the 'free other peoples' band wagon and tell us to go forth and die in a foreign land." First Lady Eleanor Roosevelt said, "The nation cannot expect the colored people to feel that the U.S. is worth defending if they continue to be treated as they are treated now." Using the slogan "We loyal Negro-American citizens demand the right to work and fight for our country," African Americans threatened to march on Washington to demand these rights. President Franklin Roosevelt issued Executive Order #8802, which

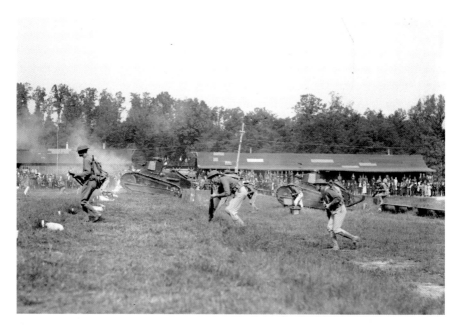

Maneuvers at Quantico Marine Corps Base before the outbreak of World War II. *Courtesy of the Library of Congress.*

Ten thousand MK-14 torpedoes were produced at Alexandria's Torpedo Factory during World War II. *Courtesy of the Library of Congress.*

opened government jobs and defense contract work to African Americans on the basis of equal pay for equal work.

Locations throughout Northern Virginia became critical to the war effort. The world's largest building—the Pentagon—was built at Arlington. The General Purpose Truck (GP or Jeep) was demonstrated at Fort Myer. Quantico Marine Base built a fifty-one-thousand-acre "Guadalcanal area" to simulate Pacific fighting conditions. Ten thousand MK-14 torpedoes were produced at Alexandria's Torpedo Factory (now the Torpedo Factory Art Center).

Near the end of the war, German prisoners of war were imprisoned in camps in Northern Virginia. Despite the fears of some local citizens over safety, the camps were approved because local farmers needed workers in this time of severe labor shortages. One camp, located near the intersection of Shirley Gate Road and Lee Highway, operated from June to November 1945. Its nearly two hundred prisoners worked as laborers on local farms. German POWs were also interned at Moss Farm near Leesburg. The POWs were picked up each morning, much like day laborers, and returned every night to the detention camp. Local farmers paid the army thirty-five cents per hour, some of which went to the POWs themselves.

Two monuments in Northern Virginia stand out memorializing the World War II era: the Iwo Jima Memorial near Arlington Cemetery commemorating the sacrifice of all U.S. Marines who have given their lives in defense of the United States, and the Netherlands Carillon, a forty-nine-bell tower given to the American people by the Dutch people in gratitude for their liberation from the evils of Nazi domination.

The First Sit-In

On August 21, 1939, five young black men walked into the Alexandria library and, one by one, asked for a library card. When the librarian refused to give them library cards, they thanked her and walked over to the book stacks, where each took a book. They then went to separate tables and began to read silently. This was a defiant and rebellious act for which the librarian, Katherine Scoggin, was not prepared. She told the young men they must leave. They continued to read.

Startled and unsure what to do next, Scoggin ran across the street and informed the city manager, Mr. Budwesky, of the events taking place at the

library. Budwesky called the police. Officer John F. Kelley arrived at the library and told the youths that they must leave the library or be arrested. They refused to leave. Kelley pleaded with them, telling them that if they went quietly no more would be said about the matter. They refused to leave. They were arrested and peacefully taken to jail. Such are the bare facts of the first sit-in of the modern civil rights movement.

Located on the site of a Quaker burial ground, on a half acre of privately donated land, Alexandria's first "free" public library opened in 1937. Like other public facilities in the South, the tacit assumption of the white community was that the library was for "whites only," in keeping with the 1896 Supreme Court decision in *Plessy v. Ferguson*, which stipulated that "separate but equal" accommodations were constitutional under the law. Attorney Samuel Wilbert Tucker was not happy about this state of affairs. Tucker passed the new Alexandria library daily, but as an African American he was unable to use the facility and had to travel to the District of Columbia to have access to library facilities. Unsatisfied with the unequal access to educational facilities, Tucker decided to battle the system in the courts.

Tucker believed that tax-paying African American residents of Alexandria had as much right as the city's white taxpayers to enjoy the public library. On March 17, 1939, Tucker and retired army sergeant George Wilson walked through the doors of the segregated Queen Street library. Wilson requested an application for a library card. The assistant librarian on duty told him that the staff had been directed not to issue library cards to "persons of the colored race." Two weeks later, head librarian Katherine Scoggin reiterated the policy when Tucker and Wilson returned. Tucker prepared the case, and Wilson filed suit in local court against Ms. Scoggin to force her to issue a library card to Sergeant Wilson as a tax-paying citizen of the city of Alexandria. While the case dragged ponderously through the legal system, Samuel Tucker planned his next move.

Tucker recruited and secretly trained eleven youths between the ages of eighteen and twenty-two over a period of ten days. Tucker told them what to say, what to wear and how to act. Borrowing heavily from the tactics utilized by successful labor protesters in the late 1930s, Tucker instructed the youths that once they were refused a library card they should

> *say thank you, go to the stack, pick up a book, any book, and go to the table and sit down and start reading. Next person goes in, and same thing but don't go to the same table, everyone goes to a different table, so they can't be talking to each other.*

Tucker next alerted the national media that something was going to happen at the Alexandria library on August 21.

Otis L. Tucker, twenty-two; Edward Gaddis, twenty-one; Morris Murray, twenty-two; William Evans, nineteen; and Clarence Strange went to the library on August 21 and were subsequently arrested for "disorderly conduct." At the trial, Samuel Tucker cross-examined the policeman who had arrested the five youths.

"Were they destroying property?" asked Tucker.

"No," replied the officer.

"Were they properly attired?" queried counsel.

"Yes," the officer replied.

"Were they quiet?"

"Yes," the officer responded.

"Then they were disorderly only because they were black?" asked Tucker.

The officer admitted that the only disorder in question was because the men were black and the library was for white people. Tucker argued that there was no local law that forbade the use of the library based solely on race. Judge Duncan instructed the attorneys to file briefs based only on a charge of disorderly conduct. The judge, not wanting to make an official ruling in the case, never recalled it before his court again.

On January 10, 1940, Judge William O. Wooll, weighing in on the earlier attempt by Sergeant George Wilson to obtain a library card, affirmed that "there were no legal grounds for refusing the plaintiff or any other bona fide citizen the use of the library." The Virginia Public Assemblages Act of 1926 stated that both races were to be segregated within the same facility; therefore, according to the law, African Americans were unlawfully barred from the Alexandria library.

On January 12, 1940, the city council of Alexandria approved funding for a new colored library. Samuel W. Tucker was not happy with this solution to his efforts to gain access to the Alexandria library for African Americans. He knew that although the existing library and the new library for colored people were required by law to be "separate but equal," in practice they would be separate but not equal.

Tucker's legal strategy was brilliant, but the Alexandria sit-in suffered from timing problems beyond Tucker's control. On September 1, 1939, all other news was swept aside as Hitler invaded Poland and World War II began in Europe. It was now the life-and-death exigencies of war that caught people's attention. Still, the Alexandria sit-in was the first hint of the winds of change that would soon sweep across America.

THE COLD WAR

With the end of World War II, America entered into the prolonged task of containing international communism, the so-called Cold War. With Pearl Harbor still fresh in America's memory, the threat of a surprise attack by foreign enemies was considered not only possible but also likely. On January 12, 1951, President Harry S. Truman signed the Civil Defense Bill designed to protect Americans in the event of nuclear war. The Civil Defense Administration encouraged families living within a ten-mile radius of the city of Washington to prepare bomb shelters. The government distributed booklets that showed people how to prepare shelters, from sandbags in the basement to elaborate underground shelters that included ventilation. All shelters were to be stocked with food, medicine and supplies to last a family for at least seven days. Those who could not afford shelters were encouraged to stock their basements with food and water and seal the basement windows against radiation. Schoolchildren were routinely drilled in air raid procedures. At the sound of the air raid siren, children were instructed to "duck and cover" under their desks, with their noses touching their knees. Television and radio programs were routinely interrupted for tests of the Emergency Broadcast System (known as CONELRAD from 1951 to 1963). The Northern Virginia Regional Defense Council released evacuation plans that designated routes to move 650,000 residents out of the blast zone.

In 1954, the army announced the construction of sixteen Nike missile sites encircling the Washington-Baltimore area. Three of these sites were located in Northern Virginia near Fairfax Station, Lorton and Great Falls. Nike missiles were designed to shoot down long-range Soviet bombers and gave local residents some feeling of safety, at least until the late 1960s, when the development of Intercontinental Ballistic Missiles (ICBMs) made the Nike missile obsolete. All of the Nike sites in the area were closed by 1974.

The Cold War reached a fever pitch in 1962, when the Soviet Union introduced long-range nuclear missiles into Cuba. On Monday evening, October 22, 1962, at 7:00 p.m., President John F. Kennedy addressed the nation in a televised, seventeen-minute speech:

> *Within the past week, unmistakable evidence has established the fact that a series of offensive missile sites are now in preparation on the imprisoned island. The purpose of these bases can be none other than to provide a nuclear strike capability against the Western Hemisphere.*

The president imposed a naval blockade on Cuba, and for six long days the world teetered on the brink of nuclear war as Soviet freighters carrying the offensive missiles approached the blockade. On October 28, the president announced that Soviet premier Nikita Khrushchev had agreed to dismantle the bases and remove the missiles already in Cuba.

The immediate crisis was over, but tensions remained high for decades to come. Advancing technology made conventional defense obsolete. The only deterrence remaining was the fear of Mutual Assured Destruction (MAD). In 1979, the Congressional Office of Technology Assessment released a report entitled "The Effects of Nuclear War," which outlined what residents of Northern Virginia could expect in the event of war. If a one-megaton hydrogen bomb was detonated (eighty times more powerful than the atomic weapon used against Japan) on the earth's surface, the following results could be expected: (1) within 1.7 miles of the blast, 98 percent of the population would be killed and nothing recognizable would still stand within a half mile of the blast crater, which would be two hundred feet deep and one thousand feet in diameter; (2) within 2.7 miles of the blast, 50 percent of the population would be killed outright, homes would be reduced to their foundations and larger buildings would leave behind skeletal remains; (3) within 4.7 miles of the blast, 5 percent of the population would be killed and most buildings would be destroyed or severely damaged. Compounding the nightmare scenario was the strategy of both sides at the time to hit targets with more than one means—ICBM and submarine-launched missiles—and with multiple missiles to ensure that the targets were completely destroyed. The attitude of one person who lived through the Cold War in Northern Virginia pretty well sums up the fears of the times:

> *When I was growing up in Annandale in the '60s, listening to the air raid siren down the street each week and the Emergency Broadcast System tests on the radio, I assumed that the world would be blown up before I was forty. But that I wouldn't have anything at all to worry about personally, as I'd have been incinerated very early on.*

Another aspect of the Cold War was espionage. Not surprisingly, the Washington area was a hotbed of spy v. spy activity. Two of the most notorious traitors emerging from the Cold War era were native-born Americans living in Northern Virignia. Aldridge Ames, a CIA employee, became the best-paid traitor in American history by selling secrets to the Soviets for some $5 million in the late 1980s. This information resulted in

the deaths of ten counterintelligence agents working for the United States. Colleagues became suspicious when Ames began living a lavish lifestyle far beyond his apparent means, at one point paying cash for an expensive home in Arlington. Ames was arrested in 1994 and is serving a life sentence without parole. Even more notorious was Robert Philip Hanssen, an FBI agent who spied for the Soviet and Russian intelligence services against the United States for over twenty-two years. Hanssen's activities have been characterized as "possibly the worst intelligence disaster in U.S. history." Hanssen was arrested on February 18, 2001, at Foxstone Park (a favorite secret drop-off point for the spy) near his home in Vienna, Virginia. Hanssen is serving a life sentence without parole.

People and Places

While Northern Virginia has often been the stage for unfolding historical dramas of national significance, this region is like every other in the country in responding to the rhythms of life—birth, death, weather, the passage of time. And when all of the captains and all of the kings have passed away, it is these rhythms of life that will continue. Every road and building tells a story, whether it be a road dating to colonial times or a new chicken eatery with a bilingual sign over the front door. How did this come to be? When? Why? Who was involved? Every place encompasses the story of people, and the story of people interacting is the stuff of history.

Arlington House

George Washington Parke Custis, at age three, inherited 1,100 acres of land overlooking the Potomac River when his father, the stepson of General George Washington, died in 1781. Young "Wash" and his sister, "Nelly," were raised at Mount Vernon by George and Martha Washington. Upon reaching legal age in 1802, the young man began building a lavish house on a high hill overlooking the Potomac; this was to be not only his house but also a living memorial to George Washington (who died in 1799). Originally, the name "Mount Washington" was considered for the house,

but in the end it was named after the Custis family estate in the Virginia Tidewater area and became known as Arlington House. The house took sixteen years to complete.

Custis married and had one daughter, Mary. Mary Custis, one of the wealthiest heiresses in Virginia, fell in love with a penniless soldier, Robert E. Lee. Although Lee came from a prominent family, at the time of his birth there was no family fortune left. Lee had only his army pay and his person to offer a bride. One afternoon, while taking a break from reading aloud from a novel by Sir Walter Scott, Lee proposed to Mary. Mary's father reluctantly agreed to the marriage.

In 1857, Custis died. His will allowed Mary to live in and control Arlington House for the duration of her life, at which point the house would pass to her eldest son, George Washington Custis Lee. Mary and Robert E. Lee lived in Arlington House until 1861, when Virginia seceded from the Union and Lee went south to join the Confederate army.

Union troops moved into Virginia in May 1861, immediately taking up positions around Arlington House. Two forts were built on the estate, Fort Whipple (now Fort Myer) and Fort McPherson. The property was confiscated by the Federal government when property taxes were not paid in person by Mrs. Lee. The property was offered for public sale on January 11, 1864, and was purchased by a tax commissioner for "government use, for war, military, charitable and educational purposes." More than 1,100 freed slaves were given land around the house, where they farmed and lived during and after the Civil War.

After the forced sale of the property, Brigadier General Montgomery C. Meigs, commander of the garrison at Arlington House (and quartermaster general of the Union army), enters the picture. Meigs and Lee had served together many years earlier as military engineers on the Mississippi River. Lee was a first lieutenant and Meigs, his subordinate, a second lieutenant. Did Meigs bear Lee a personal grudge? Some historians think so, or perhaps he was just embittered by the war or by Lee's defection from the Union army. In any event, tasked with finding additional burial grounds for battle casualties, on June 15, 1864, Meigs wrote to Secretary of War Edwin Stanton that "the grounds about the mansion are admirably suited to such a use." Meigs himself reported his "grim satisfaction" of ordering twenty-six Union dead to be buried near Mrs. Lee's rose garden in June 1864. Meigs had graves dug right up to the entrance to the house. The entire rose garden was dug up, and the remains of some 1,800 soldiers recovered from the Manassas Battlefields

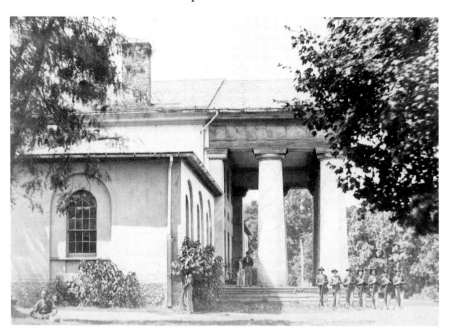

Arlington House, the former residence of Robert E. Lee, in 1864. *Courtesy of the Library of Congress.*

were buried there in a huge burial vault. Such an unusual positioning of graves was malicious. Meigs's intention appeared to be to prevent the Lee family from ever again inhabiting the house. By the time the Civil War ended, more than 16,000 Union soldiers had been buried on the grounds of the estate. Ironically, Meigs's own son was killed in October 1864 and sent to Arlington Cemetery for burial.

Neither Robert E. Lee nor his wife ever set foot in Arlington House again. General Lee died in 1870. Mary Custis Lee visited the grounds shortly before her death in 1873 but was overcome by emotion and was unable to go inside the house. After the death of his parents, George Washington Custis Lee claimed that the house and land had been illegally confiscated and that, according to his grandfather's will, he was the legal owner. In December 1882, the U.S. Supreme Court, in a five-to-four decision, returned the property to George Washington Custis Lee, stating that it had been confiscated without due process. Would the dead have to be transferred to a new site? General Lee's son diffused the crisis by selling the house and land to the government for its fair market value.

In 1920, Alexandria County was renamed Arlington County to honor Robert E. Lee and to end the ongoing confusion between Alexandria

County and the independent city of Alexandria. Arlington House itself was subsequently dedicated to the memory of Robert E. Lee.

We may never know what motivated Montgomery Meigs, but history may have misjudged him. In 1884, when Armistead Lindsay Long was compiling information for a book on the life of Robert E. Lee, Meigs contributed the following remembrance of the Lee he knew in his youth:

> [He was] *a man then in the vigor of youthful strength, with a noble and commanding presence, and an admirable, graceful, and athletic figure. He was one with whom nobody ever wished or ventured to take a liberty, though kind and generous to his subordinates, admired by all women, and respected by all men. He was the model of a soldier and the beau ideal of a Christian man.*

Today, the rolling hills beneath Arlington House contain the final resting places of more than 250,000 American heroes.

TOWN NAMES

Alexandria, Fairfax, Leesburg, Manassas, Woodbridge—you drive through them every day, but what do you know about their origins? Everyone knows how Washington got its name, but do you know how the cities and towns of Northern Virginia were named?

Alexandria is named after the original owner of the land upon which it was established: Scotsman John Alexander. Alexander purchased the land that included the future site of Alexandria in 1669 for "six thousand pounds of Tobacco and Cask." John West, the Fairfax County surveyor, laid off sixty acres (by tradition, assisted by seventeen-year-old George Washington), and lots were auctioned off on July 13 and 14, 1749.

Fairfax County and Fairfax City derive their names from Thomas Fairfax, sixth Lord Fairfax of Cameron, who once owned five million acres of land in Northern Virignia. Lord Fairfax traveled to Virginia in 1735 and subsequently set up permanent residence in Clarke County in 1752. Lord Fairfax was the only British peer to reside permanently in colonial America. A Tory during the American Revolution, Lord Fairfax's land was confiscated in 1779.

McLean was named after John R. McLean in 1910, when the communities of Lewinsville and Langley merged. McLean, the owner of the *Washington Post*, helped finance an electric rail line connecting the area with Washington.

The area of Fairfax County known as Burke is named for Silas Burke (1796–1854), a nineteenth-century farmer, merchant and local politician. Burke donated right of way to the Orange and Alexandria Railroad in the late 1840s, and a railroad station near his house was named Burke's Station.

Herndon was named for William Herndon, the captain of the ill-fated steamer SS *Central America* who heroically went down with his ship in 1857 after helping to save over 150 passengers and crew.

In 1961, developer Robert E. Simon purchased a large tract of land in Northern Virignia. On his fiftieth birthday, April 20, 1964, Simon founded the planned community of Reston. Reston takes its name from Robert E. Simon's initials.

In 1757, the Assembly of Virginia selected the settlement of George Town for the location of the Loudoun County Courthouse. The town's name was changed to Leesburg, for the Lee family, by an act of assembly in September 1758 that officially established the town. Initial town trustees included Nicholas Minor, Philip Ludwell Lee and Francis Lightfoot Lee, who were responsible for regulating building in the town.

The area around Hamilton was originally known as Harmony, named for a nearby estate. In 1835, the postmaster general approved a post office location in Hamilton's store. The settlement's name was thereafter recorded as Hamilton.

Originally known as the German Settlement, local developer David Lovett renamed the area Lovettsville in 1820. Lovett subdivided his property into "city lots." A construction boom ensued, and the settlement was imaginatively renamed Newtown. In 1828, the town was again renamed Lovettsville.

Brentsville takes its name from George Brent, who, with three others, was granted a thirty-thousand-acre tract called the Brent Town Tract in 1687. Brent envisioned founding a sanctuary for people of all faiths. The great plan came to little, and the land was divided among the four partners.

Bristow is named after Robert Bristow, one of George Brent's partners. It stands on Bristow's share of the Brent Town Tract.

Nokesville stands on land once owned by the Nokes family. The land was sold to James Nokes in 1859. The town grew up around the Nokeses' home, White Hall.

While many of the towns we know today were named after worthy citizens, some town fathers were more crafty than worthy. Thomas Gaines, a canny

Welshman, owned the area around the modern town of Gainesville in the mid-nineteenth century. The Manassa's Gap Railroad sought right of way through his land around 1852. Gaines agreed, provided that all passenger trains stopped on his land and that the stopping point be called Gainesville.

The names of some towns are shrouded in mystery. The true origins of the name Manassas cannot be definitely established. Several theories have developed. One theory says the name is of unknown Indian origin. The most commonly accepted theory ascribes the name to a very early settler. An old Frenchman named Manassa lived in the gap that cuts through the Blue Ridge Mountains. Thus, the area became known as Manassa's Gap. In 1850, the General Assembly authorized the construction of a railroad through the gap; the company was named the Manassa's Gap Railroad Company. The point at which the Manassa's Gap Railroad split off from the Orange and Alexandria Railroad became known as Manassa's Junction. The apostrophe was gradually dropped from the name, and by the time of the Civil War it was no longer in general use. The "Junction" part of the name was also gradually deleted. When the town was incorporated in 1873, it was named simply "the Town of Manassas."

There is no mystery about the origin of the name Woodbridge. In 1681, the General Assembly directed that a "boat be kept at such place on the Occoquan as the chief officers of the county shall appoint." The ferry united the main roadway to the north and south. Later, a wooden bridge replaced the ferry, which explains the present name Woodbridge.

Some town names derive from Native American sources. The towns of Occoquan and Quantico have Native American names. *Occoquan* means "at the end of the water." *Quantico* means "the long stream."

Some town names honor and remember old bonds. Dumfries gets its name from the old home in Scotland of John Graham, one of the first of the notable Scots who settled in the area. In 1746, he acquired 136 acres on the north side of the Quantico stream for development. It was here that the town of Dumfries was established.

Once known as Alexandria County, the current Arlington County was renamed in 1920 after the Custis-Lee mansion previously known as Arlington. This mansion, in turn, derived its name from a much earlier plantation on Virginia's eastern shore named after the seventeenth-century Earl of Arlington.

Springfield was founded as a station on the Orange and Alexandria Railroad in 1847. The station was named for the estate of Alexandria businessman Henry Daingerfield, on whose land the station had been built.

The town of Vienna was originally called Ayr Hill, after the name of the house built by early settler John Hunter, who named it after the place of his birth: Ayr, Scotland. The name of the town was changed in the 1850s, when a doctor named William Hendrick offered to move there if the town would rename itself after his hometown: Vienna, New York.

Known as Devereux Station during the Civil War (the sixth stop on the Orange and Alexandria Railroad between Fairfax Station and Union Mills), the surrounding settlement was renamed Clifton after the hometown (Clifton, New Jersey) of northern developer Harrison G. Otis, who bought up much of the surrounding land after the Civil War.

Both Stafford County and the town of Stafford are named for Staffordshire, England.

Some town names are more descriptive than imaginative. Middleburg was renamed in 1787 by Levin Powell, an officer in the Revolutionary War. Powell purchased the land from Joseph Chinn, a first cousin of George Washington. Powell chose the name Middleburg for the area previously called Chinn's Crossroads because of the town's location midway between Alexandria and Winchester.

Falls Church takes its name from a church orignally built in 1734. The church was commonly known as "the Falls Church" because it was located on the main road between Great Falls and the Potomac.

Perhaps historians in the future will puzzle over the names of Dale City, Landsdowne and Crystal City.

CEMETERIES

Old cemeteries and tombstones tell us much about the lives, tastes and aspirations of people across the centuries. One of the oldest and most decorative tombstones in Northern Virginia dates from 1690 and belongs to Rose Peters, buried in Prince William County. The inscription reads, "She is gone, o she is gone to everlasting rest, to Christ our beloved Savior who loves sinners best." Nothing is definitely known about Rose Peters other than that she was a sinner, having been expelled from Middlesex, England, in 1685 for moral behavior unacceptable to her neighbors. Even after death, trouble plagued Rose Peters. Her headstone (but not her body) was moved by court order in the 1960s from its original site near Neabsco Creek to Rippon

Lodge to prevent vandalism. The headstone moved into the Blackburn family cemetery. The Blackburns were prominent colonial gentry. One of the most impressive stones in this cemetery tells us, "Here lieth the Body of Col. Richard Blackburn," who died July 15, 1757, "preferred by the Governor to the Most Eminent Stations and Command in the Colony." The tombstone goes on to tell us that he was a man of consummate prudence, frugality and industry, "whereby he made a large fortune in a few years."

Most tombstone elegies are more concerned with philosophy than biography. One early tombstone elegy from Lake Ridge in Prince William County reminds us, "Remember reader as you pass by, as you are now so once was I, as I am now you must be, prepare for death and follow me."

Perhaps the most romantic tombstone in Virginia is that of Alexandria's "Female Stranger." In September 1816, a young couple arrived in Alexandria. The lady was very ill. She remained in her room at a local inn until her death. After her death, her husband erected a tomb, left the city and was never seen again. Her tombstone reads:

> To the Memory of a
> *FEMALE STRANGER*
> *whose mortal sufferings terminated*
> *on the 14th day of October 1816*
> *Aged 23 years and 8 months.*
> *This stone is placed here by her disconsolate*
> *Husband in whose arms she sighed out her*
> *latest breath and who under God*
> *did his utmost even to soothe the cold*
> *dead ear of death.*
> *How loved how valued once avails thee not*
> *To whom related or by whom begot*
> *A heap of dust alone remains of thee*
> *'Tis all thou art and all the proud shall be.*
> *To him gave all the Prophets witness that*
> *through his name whosoever believeth in*
> *him shall receive remission of sins.*
> *Acts. 10th Chap. 43rd verse*

The identity of the Female Stranger remains a mystery. What secret did the young couple hide? Were they eloping? Was she an English aristocrat, royalty, the daughter of a prominent politician? The mystery lingers beyond the grave.

One of the oldest cemeteries in the area is located at the Old Presbyterian Meeting House in Alexandria. Most of the graves here date to the eighteenth century, and most of those buried here were either personal friends of George Washington or known to him. The most unusual grave here is the Tomb of the Unknown Revolutionary War Soldier. In 1826, workers digging a foundation behind the Old Presbyterian Meeting House found an unmarked grave with an ammunition box serving as a coffin. The tattered uniform of the grave's occupant identified him as a Revolutionary War soldier, and the buttons on the uniform indicated that he was from Kentucky. The soldier's remains were reinterred in the cemetery behind the meetinghouse. In 1929, a memorial was created. An inscription placed on the table tomb at the dedication of the memorial reads:

Here lies a soldier of the Revolution whose identity is known but to God. His was an idealism that recognized a Supreme Being, that planted religious liberty on our shores, that overthrew despotism, that established a people's government, that wrote a Constitution setting metes and bounds of delegated authority, that fixed a standard of value upon men above gold and lifted high the torch of civil liberty along the pathway of mankind. In ourselves this soul exists as part of ours, his memory's mansion.

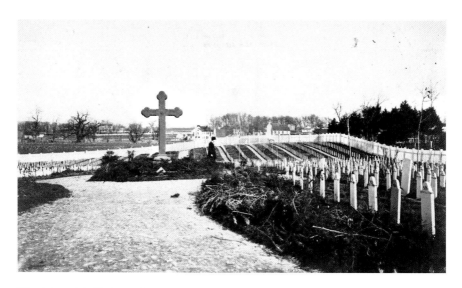

The Alexandria National Cemetery (one of the earliest national cemeteries) was created during the Civil War. *Courtesy of the Library of Congress.*

Sometimes a cemetery has to be rediscovered before it can speak. Such was the case of the Freedemen's Cemetery on South Washington Street in Alexandria. The Freedmen's Cemetery was created during the Civil War as a burial place for the former slaves who were fleeing the Confederacy and flocking to Alexandria. Initially, African American soldiers fighting in the Union army were also buried here, but these soldiers were reburied at the newly created Alexandria National Cemetery (one of the earliest national cemeteries) before the end of the war. Some 1,800 freedmen were buried in the Freedmen's Cemetery. Over time, the wooden markers memorializing the dead at the Freedmen's Cemetery decomposed. In the 1930s, the George Washington Memorial Parkway was built over part of the graveyard. Construction of the beltway destroyed the southern edge of the cemetery. In 1955, a gas station was built on top of the remaining graves. The cemetery was rediscovered by archaeologists and historical researchers in the activity surrounding the expansion of the Woodrow Wilson Bridge, and it was purchased by the City of Alexandria in 2007. On May 12, 2007, the site was rededicated as the Freedmen's Memorial Park.

AVIATION COMES TO NORTHERN VIRGINIA

Northern Virginia has always hosted air traffic coming to the nation's capital, but in the early days, Washington had the reputation of having the poorest aviation ground facilities of any important city in the United States or Europe. Wiley Post, the first pilot to make a solo flight around the world, said that "there were better landing grounds in the wilds of Siberia than at Washington."

Thomas Mitten, the owner of the Pennsylvania Rapid Transit Company of Philadelphia, opened the first airfield in the Washington area in 1926, hoping to reap huge profits by flying Washingtonians to Philadelphia for the 150th-anniversary celebration of the Declaration of Independence. Mitten's Hoover Field was located on a thirty-six-acre tract in Arlington where the Pentagon now stands. Mitten sold the airfield after only six months to the Potomac Flying Service. This company took over twenty-five thousand passengers for sightseeing flights over the nation's capital from 1926 to 1928. A competing airfield, Washington Airport, opened across the road to the south on ninety-seven acres. Seaboard Airlines was

established here in 1928 and began flying one daily round-trip flight to New York City.

In 1930, at the height of the Great Depression, the owners of both Hoover Field and Washington Airport sold out to the National Aviation Corporation, which merged the two airfields into a new facility called Washington-Hoover Airport. The new owners built a modern terminal and a new hangar. The new terminal boasted a passenger waiting room on the lower floor. The airport also offered a large outdoor swimming pool for the enjoyment of the sightseers who converged on the airport. The pool served as an important source of revenue.

Despite improvements, Washington-Hoover could not overcome its structural defects. The airport's single runway was intersected by a busy street, Military Road. Guards were posted on this road to stop oncoming auto traffic during takeoffs and landings. Additionally, due to its low-lying location next to the Potomac River and its poor drainage, the airport was prone to flooding. Bordered on the east by Route 1 with its high-tension electrical wires, obstructed by a high smokestack on one approach and with a dump nearby, the field was increasingly unable to handle increased air traffic and newer planes. Hoover Field closed in 1941, replaced by the much larger Washington National Airport (now Ronald Reagan Washington National Airport), two miles to the southeast.

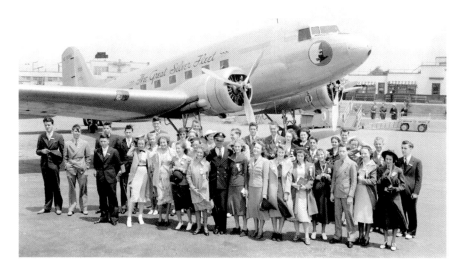

Passengers arriving at Washington National Airport, circa 1940. *Courtesy of the Library of Congress.*

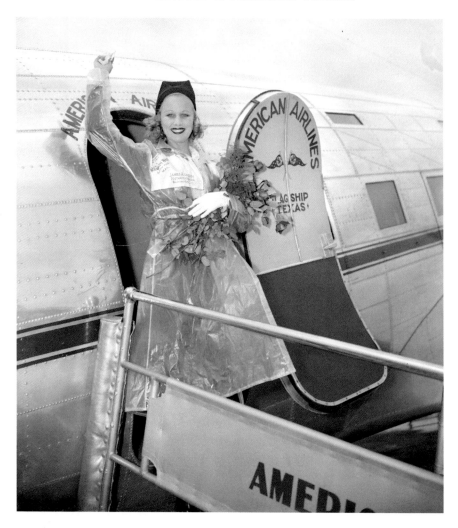

Hollywood starlet Marion Weldon arriving at Washington National Airport, circa 1940. *Courtesy of the Library of Congress.*

After World War II, Congress passed the Washington Airport Act of 1950, providing funding for a second larger airport to serve the capital region. Three sites were considered: Burke and Annandale in Fairfax County and Willard on the Fairfax-Loudoun border. In 1951, the Burke site was selected, and the U.S. Civil Aeronautics Administration announced plans to condemn 4,520 acres. An opposition effort by local residents stymied the plan for six years. Finally giving up in 1958, the government dropped Burke and selected Willard, a largely rural black community, as the site of the new

airport. Willard's eighty-seven area landowners received condemnation letters early in September 1958. In total, 9,800 acres were condemned, with the government paying some $500 an acre. Three hundred buildings were leveled to make way for the new Dulles Airport, named after President Eisenhower's secretary of state, John Foster Dulles, an aviation enthusiast. Curiously, the name Dulles caused problems for inattentive travelers, who often got off at Dulles rather than their true destination, Dallas. In 1984, Congress adopted the name Washington Dulles International Airport.

Under the heading "What Might Have Been," it should be noted that one bold entrepreneur had the dream of bringing the largest airport in the world to Northern Virginia. In the late 1920s, Henry Woodhouse purchased 1,500 acres in Fairfax County's Hybla Valley. Woodhouse dreamed of converting the existing dairy farms into the George Washington Air Junction. Woodhouse was convinced that zeppelins were the future of aviation and conceived of gigantic runways and mooring fields to accommodate transatlantic zeppelin flights. An article in the March 3, 1938 issue of the *Herald Times* proclaimed:

> *Hybla Valley, flat as a table and 3,800 acres in extent, lies 3 miles south of Alexandria, flanked by U.S. Highway #1. On it could be located the largest runways in the world, and it could be converted into the largest airport in the world.*

Nothing came of the plan, and not a single aircraft ever operated from the site. Woodhouse succumbed to his creditors, and the land was eventually purchased by the government in 1941 for use by the military. In 1975, the land was sold to Fairfax County for one dollar to be used "exclusively for public park or public recreation purposes in perpetuity." The land is now known as Huntley Meadows Park.

Bridges Across the Potomac

In 1790, Congress passed the Residence Act, which provided for the establishment of a new permanent capital city to be located on the Potomac River at a place to be selected by President Washington. Before the establishment of the new federal city, Virginians had little need for bridges to

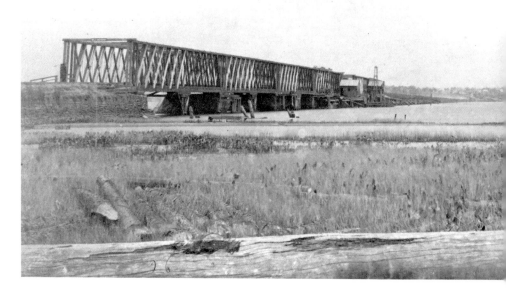

The Long Bridge across the Potomac, now occupied by the Fourteenth Street Bridge complex, circa 1865. *Courtesy of the Library of Congress.*

cross the Potomac River. Ferries were the primary means of transportation across the river, with some one hundred ferries operating along the length of the river at one time or another. Only one ferry remains today: White's Ferry north of Leesburg.

The first bridge across the Potomac was opened on July 3, 1797. The "Bridge at Little Falls," as it was first known, was an important link between the fledgling city of Georgetown and the agricultural produce of Loudoun County. This bridge was the direct ancestor of today's Chain Bridge. Shortly before the bridge opened, George Washington wrote, "The Public buildings in the Federal City go on well…An elegant bridge is thrown over the Potomack at the little Falls." The first bridge rotted and collapsed in 1804. Its immediate successor, another wooden bridge, burned six months after its completion. Four years later, a third bridge, the first to use suspension support, was built. It was destroyed by a flood in 1810. A fourth bridge was

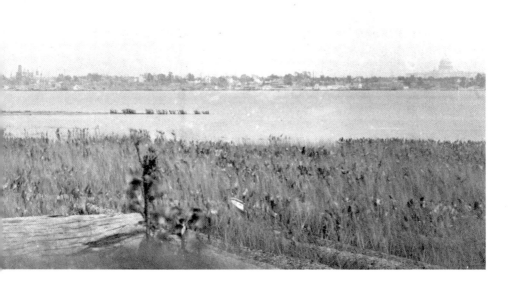

severely damaged by a flood in 1815 and was replaced by a new bridge built of chain and wood in 1840. In the 1850s, the bridge was rebuilt but was destroyed by floods in 1870. A new lightweight iron bridge was completed in 1874. This bridge was strong for the period but proved inadequate for the automobile traffic of the twentieth century and finally had to be closed after the flood of 1936. The next and current bridge was redesigned as a continuous steel girder structure and was completed in 1939.

The Long Bridge, the ancestor of the five bridges that are now collectively known as the Fourteenth Street Bridge, was a wooden toll bridge opened in 1809 by a private firm called the Washington Bridge Company. When the British burned Washington in 1814, President Madison and other government officials escaped into Virginia across the Long Bridge. The Americans then destroyed the Virginia end to prevent pursuit by the British. The British destroyed the Washington end to prevent a counterattack by the Americans. It took four years to reopen the bridge.

During the Civil War, Washington became a major military supply depot. Railroads were a relatively new invention that the military was using for the

first time. How to get supplies from Washington City across the river to the battle front in Virginia became a central concern of war planners. Rails were placed on Long Bridge, but fearing that the structure might collapse under the strain of too much weight, the generals had horses pull railroad cars and engines across the river into Virginia. A new stronger bridge dedicated solely to rail traffic was built one hundred feet downstream, but this bridge was not operational until the war was almost over. The Long Bridge was frequently damaged by floods over the following decades but served until 1906, when it was replaced by the Highway Bridge. The traffic in 1906 seems light compared to the 250,000 automobiles that now pour across the Fourteenth Street Bridge daily. At the turn of the century, the average daily traffic over the Highway Bridge was fifty-two single electric trolley cars, two hundred two-car trains, some 100 automobiles, eight hundred double-animal teams, four hundred single-animal teams, five hundred pedestrians and eight horsemen.

The river crossing from Northern Virginia into Georgetown, now the Francis Scott Key Bridge, was originally the site of the Alexandria Aqueduct

Arlington Memorial Bridge under construction, circa 1931. *Courtesy of the Library of Congress.*

Bridge. In 1830, Congress granted a charter to the Alexandria Canal Company to construct an aqueduct bridge that would carry canalboats across the Potomac and downriver on the Virginia side without unloading in Georgetown. The water-filled bridge was built of weatherproofed timbers. The Aqueduct Bridge, completed in the 1840s, remained in operation until the Civil War. In the 1880s, the old bridge was sold to the federal government and replaced by a light iron bridge. Congress authorized the complete replacement of the aging Aqueduct Bridge in 1916. The Francis Scott Key Bridge was constructed by the Army Corps of Engineers from 1917 to 1923.

The 1930s saw the construction of two new bridges across the Potomac. The Arlington Memorial Bridge, widely regarded as Washington's most beautiful bridge, was opened on January 16, 1932. Memorial Bridge was designed to symbolically link the North and South in its alignment between the Lincoln Memorial and Arlington House, the Robert E. Lee Memorial. The functional Point of Rocks Bridge connecting Loudoun County with Maryland was completed in 1937.

The late 1950s and early 1960s were the heyday of bridge building in Northern Virginia. As part of the Interstate Highway System created by Congress in 1956, the Woodrow Wilson Memorial Bridge was opened in 1961. The American Legion Memorial Bridge, originally known as the Cabin John Bridge, was built in 1963. The Theodore Roosevelt Bridge, connecting Rosslyn to Washington, was opened on June 23, 1964.

DISASTERS: NATURAL AND UNNATURAL

Weather information goes back a long time in Virginia, thanks to record-keeping by observers such as George Washington, James Madison and Thomas Jefferson. Snow is the most common form of natural disaster in Northern Virginia. George Washington recorded that on January 28, 1772, a gigantic snowstorm left thirty-six inches of snow on the ground in Northern Virginia. This number is the unofficial record for the area, assuming that Washington's measurements were accurate. Washington also reported a late-season cold snap, with spits of snow and a hard wind on May 4, 1774. During the winter of 1783–84, the Potomac River froze over in November and the ice did not break up until March 15. The previous year,

Ice jams on the Potomac River. *Courtesy of the Library of Congress.*

an entire regiment of the Virginia infantry had marched across the frozen Rappahannock River.

The great winter events of the nineteenth century were the "Great Arctic Outbreak of '99" and the "Great Eastern Blizzard of '99." On February 11, Quantico recorded a record low of minus twenty degrees Fahrenheit. The blizzard struck on Valentine's Day, dropping thirty-four inches on Northern Virginia. The winter of 1898–99 was so cold throughout the United States that ice flowed down the Mississippi River into the Gulf of Mexico.

January 1977 was the coldest winter on the East Coast since colonial times. The Potomac River froze solid, and people skated from Northern Virginia to Washington near Memorial Bridge. The cold wave penetrated so far south that snowflakes were seen in Miami, Florida, on January 19.

During a snowstorm on January 13, 1982, the most calamitous weather disaster in Northern Virginia's history occurred when Air Florida Flight 90 clipped the commuter-packed Fourteenth Street Bridge, knocking cars into the icy Potomac before crashing into the river and breaking apart. Five surviving passengers clung to the tail section of the airliner that jutted out of the ice-choked Potomac River as rescue workers tried to get to them. During

the rescue operations, one passenger, Priscilla Tirado, was too weak to reach the rescue line dropped from a helicopter. As hundreds of people watched, including emergency service personnel, Lenny Skutnik, a government employee from Prince William County commuting home, dove into the icy water to assist Tirado. Skutnik saved the woman's life. For this act, he was invited into the presidential gallery at the 1982 State of the Union address. On January 26, 1982, President Ronald Reagan praised Skutnik's heroism in the televised address before the joint session of Congress. Since then, honoring unselfish acts of bravery has become a traditional part of the State of the Union ritual. The presidential gallery is now sometimes referred to as the "Heroes' Gallery."

With the exception of snow, Northern Virginia is not prone to the types of natural disasters that strike other parts of the country, but for every rule there is an exception, and a number of unusual natural occurrences have helped make history in the area. On February 21, 1774, a strong earthquake was felt over much of Virginia. According to scientists, almost any part of Virginia is apt to feel the occasional earthquake. On March 9, 1828, an earthquake, centered in southwestern Virginia, attracted the attention of President John Quincy Adams as it rattled windows in Washington. President Adams reported that the tremor felt like the heaving of a ship at sea. In March 1918, an earthquake centered in the Shenandoah Valley broke windows in Washington and rippled over Northern Virginia. The tremor caused a terrifying noise and was commented on by President Wilson at the White House. A White House staffer called a newspaper office to learn the cause of the terrifying noise. Since 1977, Virginia has experienced some two hundred earthquakes, most of them small.

Virginia is considered to be at moderate earthquake risk, with a 10 to 20 percent chance of experiencing a 4.75 Richter scale quake. Quakes over 4.5 on the Richter scale topple buildings. Virginia's most severe earthquake (5.8 on the Richter scale) occurred on May 31, 1897, in Pearisburg, the county seat of Giles County, in southwest Virginia. Closer to home, small earthquakes have startled local citizens. On September 29, 1997, a 2.5 Richter scale earthquake struck Manassas. One local resident reported that he was "shaken, not stirred," after hearing what sounded like an unusually large sonic boom. On May 6, 2008, a so-called micro-earthquake (magnitude 1.8) struck Annandale. Approximately one thousand micro-earthquakes happen every day throughout the world and are only noticed if they hit high-population-density areas where they are most often noticed by people living in high-rise buildings.

One of the most peculiar natural phenomena to strike Northern Virginia was a gigantic dust storm blowing in from the Great Plains. Years of environmental mismanagement on the Great Plains set the stage for a natural calamity. In 1931, a drought hit the region. Crops dried up, and because the ground cover keeping the soil in place was gone, the naturally windy area began whipping up dust. Dust storms became problematic and continued to grow in intensity. In 1934, an enormous storm drove 350 tons of silt across the Great Plains as far as the East Coast. Ships three hundred miles offshore in the Atlantic reported collecting dust on their decks. In April 1935, a dust storm arrived in Northern Virginia from the Great Plains. A dusty gloom spread over the region and blotted out the sun. Meanwhile, in downtown Washington, conservationist Hugh Hammond Bennett was testifying before Congress about the need for soil conservation. Bennett explained (pointing to the darkened skies over Washington), "This, gentlemen, is what I have been talking about." Congress passed the Soil Conservation Act the same year.

POTOMAC RIVER ECOLOGY

The climate of Northern Virginia was much colder 11,500 years ago when people first migrated to the area. Great Arctic glaciers extended as far south as northern Pennsylvania. Animals and plants here were similar to those found in the far north of Canada but also included now extinct species such as mammoths. Over the next several thousand years, as the climate grew warmer, the glaciers receded. The Susquehanna River Valley gradually flooded to form today's Chesapeake Bay, and the modern Potomac River was born. Vegetation and animal life changed. Oak and hickory forests appeared, as did "modern" animal species such as deer, bear, elk and bison.

The climate of Northern Virginia became much as we know it today after approximately 2,750 BC. Prehistoric peoples became less nomadic, settling in larger camps near rivers and streams. Food was abundant and diverse. Fish could be had from the rivers. Oysters and mussels were available in season, and meat could be had from a wide variety of small mammals, reptiles and migratory birds, as well as larger game such as deer and bear. The natives called the Potomac River above Great Falls *Cohongarooton* ("river of geese").

People and Places

Washington from the Virginia side, circa 1919. *Courtesy of the Library of Congress.*

With the coming of modern civilization also came people, a great many people. The population of Virginia reached one million in 1830. Eighty years later, the population reached two million. Within the next thirty-five years the population of Virginia reached three million. It took only fifteen more years to reach four million in 1960. Since then, growth has accelerated. By 1990, the population stood at six million, and it is now projected to reach eight million by 2010. People brought pollution.

The Potomac River was particularly hard hit. With increased mining and agriculture upstream and increased urban sewage and runoff downstream, the Potomac River was slowly poisoned, creating severe eutrophication, a condition that allows the enhanced growth of choking aquatic vegetation. This disruption of the normal functioning of the ecosystem causes a variety of problems such as a lack of oxygen in the water—in short, stinking dead plants and stinking dead fish. It is said that President Lincoln used to go to the outskirts of Washington on hot summer nights to escape the river's stench. In 1965, after centuries of contamination by raw sewage and industrial pollutants, President Lyndon B. Johnson called the Potomac River a "national disgrace." President Johnson set in motion a long-term effort to reduce sewage pollution and restore the health of the Potomac. Since the mid-1960s, there have been

Fishing near the Fourteenth Street Bridge, circa 1920. *Courtesy of the Library of Congress.*

large-scale improvements at wastewater treatment plants, and the Potomac is now clean enough to support numerous bald eagles and smallmouth and largemouth bass.

The threat to Northern Virginia's waterways is far from over, however. Galloping development is replacing forests with streets, homes and shopping centers, threatening the region's streams and rivers. It took more than 350 years, from the arrival of European colonists to 1986, to cover 12 percent of the Washington area with concrete and other impermeable surfaces. From 1986 to 2000, the proportion jumped to nearly 18 percent. Northern Virginia environmentalists Chris and Lisa Bright (founders of the Earth Sangha, whose motto is "Buddhist Values in Action") report:

> *You can see one of the biggest reasons for ecological decline any time it rains. Storm water run-off—the water that rushes off lawns and streets during downpours—is an enormous but largely hidden environmental problem in urban and suburban landscapes.*

Potomac River flood, 1924. *Courtesy of the Library of Congress.*

Because so much of suburbia consists of buildings, roads, parking lots and bulldozer-compacted turf, the landscape absorbs relatively little water compared to what it once did when it was less paved and more forested. When it rains in the suburbs, a much smaller proportion of the water is now retained by plants and the soil, and a much larger proportion runs into the streams. All this runoff contaminates streams with pollution from roads and lawns. It also washes in eroded soil and erodes the stream channels themselves, sometimes dropping them so low that they lose their natural connection to their flood plains. Runoff raises water temperatures as well. Warmer water can make streams uninhabitable for many native organisms. There are secondary effects, too. For example, the warming reduces the amount of oxygen dissolved in the water, as does the incoming nitrogen and phosphorous pollution from lawn fertilizer, animal waste and eroded soils. Taken together, the pollution, deposition of sediment, erosion, warming and oxygen depletion have a ruinous effect on local stream ecology.

PRESERVING THE PAST

Northern Virginia is a transient area, but it does not take a newcomer long to realize that there is a great deal of exciting history within a stone's throw of virtually every road in the area.

Many forces threaten historical sites. Take, for example, the case of Beverley's Mill, built in 1749 and rebuilt in 1858. The historic structure, located on Route 55 on the boundary between Fauquier and Prince William Counties, is seven stories high and ground cornmeal and flour for American troops during seven wars: French and Indian, Revolutionary, War of 1812, Civil War, Spanish-American War, World War I and World War II. In the nineteenth century the mill was considered the very model of advanced agricultural technology. Not just a utilitarian structure, the imposing and beautiful structure also has an air of mystery about it, for it is the setting of several popular ghost stories. One of the legends tells of a workman at the mill who liked to drink on the job. He did this for a period of years until one fateful day he got drunk, fell asleep and was run over by a wagon. The wagon cut off his head. According to the legend, he still haunts the precincts of Beverley's Mill, carrying his severed head under his arm. It was perhaps the ghost stories that drew curious trespassers to the remote site, where they either accidentally or intentionally set a fire that gutted the historic mill in October 1998. Soon afterward, a group of citizen preservationists formed a 501(c)(3) tax-exempt charitable foundation and began the work of preserving the mill and developing an interpretive program of the history and significance of the property. Other historic sites have not been as fortunate as Beverley's Mill. Snow Hill, near Haymarket, a beautiful showplace mansion built before 1770, was burned by squatters. Waverley, another plantation in the same general vicinity, suffered the same fate. Historic cemeteries throughout the area are routinely vandalized. Even more destructive to historic properties than vandals has been the onrush of subdivisions and shopping plazas. Fort Beauregard, for example, a naturally well-preserved Civil War fortification near Manassas, was flattened to make way for a bowling alley.

Fortunately, historically minded citizens in the area have rallied to save the historical heritage of Northern Virginia. Loudoun County's efforts to preserve its heritage go back to 1942, when the county addressed the proliferation of billboards along the highways that "obscured scenic views." In 1972, Loudoun County established Historic Area Districts. In 2009, an imaginative partnership between the local activists of the Mount Zion

Preservation Association, Loudoun County and the Northern Virginia Regional Park Authority established a plan to not only preserve the historic Civil War–era church but also transfer some 147 acres to parkland.

Other areas of Northern Virginia are similarly active in protecting historic sites. The Historic Alexandria Foundation was incorporated in 1954 "to preserve, protect and restore structures of historic and architectural interest in and associated with the City of Alexandria, Virginia, to preserve antiquities and generally to foster and promote interest in Alexandria's heritage." Alexandria's preservationists influence policymakers through coordinated and sustained efforts, interacting regularly with decision-makers, attending public meetings, providing public testimony and partnering with like-minded organizations. Of its work, the foundation says:

> *Historic preservation provides an avenue to enrich and revitalize our lives and communities. It creates jobs, revitalizes downtown areas, stimulates businesses, and ultimately, makes communities more vital. Historic preservation offers tax incentives, funding possibilities, motivation for community involvement, and fosters community spirit. Historic preservation enables communities to become economically viable and livable.*

Prince William County has created a strategic plan in which preservation goals focus on the preservation of county-owned structures and their use for public and heritage tourism purposes. In 2000, Prince William County purchased Rippon Lodge (1745), one of the county's oldest and most important historic structures. The county, in cooperation with the Alliance for Revitalization of the Courthouse, the City of Manassas and the Commonwealth of Virginia, also completed the rehabilitation of the 1893 courthouse, which had been abandoned for more than fifteen years. The building now houses court offices, and the beautifully restored courtroom is available for meetings and private events. Another current project is the Historic Courthouse Centre in Brentsville, where historic structures include the 1822 courthouse and jail, a 1928 one-room schoolhouse, an early 1800s log cabin and an 1875 church. The nonprofit Historic Preservation Foundation supports the county's many historical endeavors.

Fairfax County has recognized its public stewardship responsibility toward historic sites for over forty years. In 1969, the Board of Supervisors amended the Zoning Ordinance to better protect those unique areas, sites and buildings that are of special architectural, historic or archaeological value to local residents and visitors. These heritage resources continue to be

recognized as major contributors to the quality of life in Fairfax County and to its reputation as one of the major centers for cultural tourism in Virginia and the United States.

In 2003, the City of Manassas was one of five communities across the country to win a Great Main Street Award, presented by the National Trust for Historic Preservation. This award honors exceptional accomplishments in revitalizing America's historic and traditional downtowns and neighborhood commercial districts.

Most heritage resources are located on private property; thus, preservationist strategies are largely aimed at educating property owners and providing them with incentives to protect heritage resources under their control. Lack of public awareness and lack of funds are the biggest problems facing historical preservationists.

FOOD

If you went back in time, you would soon discover that things sounded, smelled and tasted differently in the past. Consider food. In colonial Northern Virginia, the cycle for meals was totally different from the modern cycle, as were the foods served. At Mount Vernon, for example, breakfast was served promptly at 7:00 a.m., dinner at 3:00 p.m. and a light supper at 9:00 p.m. George Washington once wrote to a friend, "A glass of wine and a bit of mutton are always ready, and such as will be content to partake of them are always welcome."

In colonial Virginia, the typical breakfast was not the juice, eggs and bacon of today (or even the cereal and toast). Colonial Virginians rose early and gulped down a bowl of porridge that had been cooking slowly all night over the embers. This was accompanied with a mug of cider or beer. A typical comfortably fixed family in the eighteenth century served two courses for dinner. The first course included several meats, plus meat puddings, pancakes and fritters and side dishes of sauces, pickles and catsups. Soups were served with the first course. An assortment of fresh, cooked or dried fruits, custards, tarts and sweetmeats were served as a second course. Supper was a light meal served late, consisting of leftovers from dinner along with cider or beer.

Certain foods likely to be found on the colonial table included carrot puffs, chicken fricassee, Virginia ham, pickled red cabbage and onion soup. Even

though these foods appear familiar, the seasonings were very different from those used in modern cooking. Colonial cooks liked nutmeg and especially enjoyed a sweet taste. Salt and pepper were not heavily used. Some foods would make the modern diner blanche; rabbits and poultry, for example, were not only prepared with their heads and feet still attached, but they were also served at dinner that way.

In 1824, Mary Randolph (the first person to be buried at what is today Arlington National Cemetery) published *The Virginia Housewife*, a book on both how to cook and how to run a household. Mrs. Randolph's book was written especially for Virginia cooks. During the colonial period, wealthy families imported cookbooks from England, but these books ignored the special requirements of America. Randolph's book is regarded as the first truly southern cookbook and contains instructions for cooking everything from hearty soups to lamb and pork dishes, along with fish, poultry, sauces, vegetables, puddings, cakes and preserves. It also covers such traditional southern fare as okra soup, curry of catfish, barbecued shoat (a fat young hog), field peas, beaten biscuits and sweet potato buns, sweetbread and oyster pie, grilled calf's head, shoulder of mutton with celery sauce, fried calf's feet, pheasant "à la daub," tansy pudding, gooseberry fool (cold stewed gooseberries with custard and whipped cream), pickled nasturtiums, walnut catsup, vinegar of the four thieves, ginger wine and many other edibles from a bygone era. Many of these dishes are no longer found on the tables of Northern Virginia.

Wedding cakes were strikingly different in the past. The traditional white wedding cake did not appear in the United States until the 1860s. Prior to this, cakes served at wedding receptions were dark and spicy, like a fruitcake. Only the introduction of finely ground white flour and the manufacture of baking soda made the creation of a more refined cake possible. The heavier "fruitcake" was relegated to being the "groom's cake." In Victorian times, there were usually three wedding cakes: one elaborate cake and two smaller ones for the bride and groom. The bride's and groom's cakes were not as elaborate. Hers was white cake and his dark. Hers was cut into as many pieces as there were attendants, and often favors were baked inside for luck. Each charm had its own meaning. As for the groom's cake, according to superstition, any single woman at a wedding should go home with a slice of groom's cake and sleep with it under her pillow. That night, according to legend, she would dream of her future husband.

Strange But True?

What is it about mysterious tales that quickens the pulse and makes the heart skip? The strange, the mysterious, the oddly coincidental all speak to our need for romance and adventure, for a world where not everything is known or knowable. Most legends start with a fact, however strange, and grow from there. Even the story of Atlantis has a kernel of truth to it (the ancient Minoan civilization on Crete actually was destroyed in one horrifying day of volcanic eruption and tidal waves). Every region has its legends and tall tales, and Northern Virginia is no exception. Some things are still too strange for people to believe, but this doesn't mean that they may not be true.

Did George Washington Have a Son?

Did George Washington have an illegitimate son? We know from traditional history that George and Martha Washington were married on January 6, 1759. Both were in their late twenties. Martha, a widow, had already given birth to four children. The marriage lasted forty happy years, without issue, until the general's death in 1799. Some have speculated that Washington was sterile. Others have suggested that Martha could no longer have children because of complications from her last pregnancy. We know that Martha did not give George a son. But did the slave Venus give him a son?

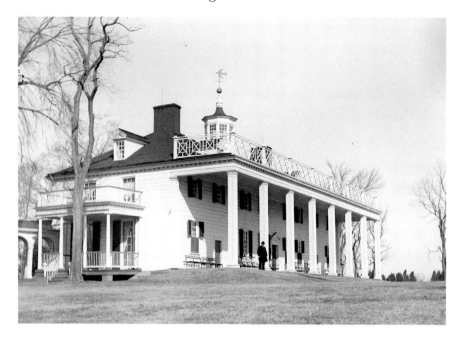

Bushrod Washington inherited Mount Vernon from his uncle George Washington. *Courtesy of the Library of Congress.*

Venus was a slave who belonged to John Augustine, George Washington's brother, who lived in Westmoreland County, some ninety-five miles from Mount Vernon. Linda Allen Bryant, a direct descendant of a slave named West Ford (1784?–1863), points to correspondence between George and his brother, John Augustine, to argue that George Washington visited his brother's plantation in 1784 and that a gap in Washington's personal diary that year could account for a sexual liaison during this visit. According to an oral tradition passed down in the Ford family—a story first publicized in the 1940s—when confronted by her mistress, Hannah Washington, the pregnant Venus confessed the paternity of her child: "The old General be the father, Mistress." Bryant makes her case in a book entitled *I Cannot Tell a Lie: The True Story of George Washington's African American Descendants.*

There is definitely evidence to support the fact that West Ford, his mother Venus and other members of his family received preferential treatment. This favored treatment, however, was given not by George and Martha Washington but by the family of John Augustine. West Ford moved to Mount Vernon in 1802, three years after George Washington died. In his will, George Washington left the Mount Vernon estate to Bushrod Washington (1762–1829), his nephew. Bushrod (later a justice of

the Supreme Court) moved to Mount Vernon and brought West Ford with him. West Ford was freed at the age of twenty-one. Freedman West Ford was employed by Bushrod Washington as an overseer at Mount Vernon for the next twenty-three years, until Bushrod's death in 1829. Ford continued to work for the Washington family after Bushrod's death, even though he had inherited 119 acres of land on nearby Hunting Creek from Bushrod. In 1833, West Ford sold this land and purchased 214 acres adjacent to it. Today, the area is known as Gum Springs. Gum Springs has some 2,500 residents, and as many as 500 are descendants of the slave families that served at Mount Vernon. After working on the Mount Vernon estate for almost sixty years, West Ford had become a well-known individual in the Mount Vernon/Alexandria area and throughout the country. He had also become the second wealthiest free black person in Fairfax County. He was not only well known but also held a prominent place in the local community, respected by whites and blacks alike.

Based primarily on the family's oral tradition, the descendants of West Ford continue to insist that George Washington is part of the family tree. At an earlier time, this claim might have been dismissed out of hand, but the case of Thomas Jefferson and Sally Hemmings requires that all of the evidence be reviewed critically and in depth. A similar scenario existed with Sally Hemmings, a slave owned by Thomas Jefferson. Her descendants claimed that Jefferson fathered one or more of Hemmings's children. Critics scoffed, but DNA analysis compared the Y-chromosome DNA from the living male-line descendants of Jefferson and Hemmings, and in 1998, the British science journal *Nature* published the results of the DNA study linking a member of the Jefferson family to Hemmings. The Thomas Jefferson Memorial Foundation, the custodians of Monticello, then issued a report in January 2000 concluding that Thomas Jefferson was the father of at least one and perhaps all of the children of Sally Hemmings. The descendants of West Ford are attempting to conduct a similar DNA analysis to prove or disprove the two-hundred-year-old family tradition.

In all likelihood, the Mount Vernon Ladies' Association argues, West Ford was indeed the son of a Washington but not George Washington. "There is some pretty strong evidence suggesting that West Ford may have been the son of another member of the Washington family." To do a DNA test such as that done in the case of Jefferson-Hemmings, one would need to have DNA from at least one living male-line descendant of West Ford and one living male-line descendant of one of George Washington's brothers or other paternal relatives. If the Y-chromosome DNA from these two

individuals matched exactly or almost exactly, that would be strong evidence that a Washington, not necessarily George, was West Ford's father. In short, at the present developmental stage of DNA science, no direct link to George Washington can be established. The Mount Vernon Ladies' Association has pledged its cooperation with testing as DNA science progresses.

The puzzle is intriguing. On the one hand, we should never suspend critical thinking and should pursue the question wherever it goes. On the other hand, we should not be gullible. Did Venus lie about the paternity of her child to save herself from punishment or sale? Was she afraid to tell Hannah Washington that it was Hannah's husband, John Augustine, or one of their sons, Bushrod or Corbin, who was actually the father, or was she honest? Did she lie to save herself, or is tradition protecting the reputation of George Washington? Time and breakthroughs in DNA science will tell the tale.

The Strange Fate of Wilmer McLean

Wilmer McLean was born in 1814, was orphaned before he was nine, was raised by relatives in Alexandria and became a prosperous food merchant in Alexandria. In 1853, he married Virginia Hooe Mason, a wealthy widow with extensive real estate holdings and other property. She owned Yorkshire plantation in Prince William County, estimated to have some 1,200 acres; a tract of 330 acres in Fairfax County; and two other tracts containing 500 acres in Prince William County. She also owned fourteen slaves. Virginia had two daughters by her first marriage, Maria (1844) and Osceola (1845). Both girls lived with the Wilmer McLeans at Manassas and were described as McLeans's "two pretty daughters." Two children were born of the McLean marriage, Wilmer McLean Jr. (1854) and Lucretia Virginia (1857).

Following the First Battle of Manassas, Mrs. McLean and the children left the area. Wilmer McLean, however, worked diligently as a civilian with the Confederate Quartermaster Department. He worked to expedite the flow of food supplies to the troops in camp near Manassas. There was a time when the troops were down to one day's rations. McLean's experience as a wholesale merchant was invaluable in solving the problem of purchasing supplies in the fertile country around Manassas.

McLean's most valuable contribution to the Confederacy was agreeing to let the army take over the buildings of Yorkshire plantation for use as a

military hospital. The barn was used as the hospital, and the main house and outbuildings were used as living quarters for the surgeons and hospital attendants from July 17, 1861, until February 28, 1862. By 1862, however, McLean had become completely disenchanted by the misconduct of soldiers and hospital personnel at Yorkshire. Large quantities of wine and whiskey were consumed by the hospital attendants. Sanitation was woefully lacking—flies covered the faces of patients. The house and outbuildings were grossly mistreated while occupied by surgeons and attendants.

Further evidence of McLean's disillusionment was his growing price demands on the quartermaster. McLean apparently purchased candles and other scarce items in Richmond, had them shipped to Manassas and then sold them to the Confederate quartermaster for the highest price he could get.

When the Confederate army marched out of Northern Virginia in March 1862, McLean left the area, permanently moving his family and household goods to central Virginia, far from the sound of battle. From his experience as a merchant McLean knew that a long war would cause the price of commodities to rise higher and higher. He began speculating in sugar and made a tidy income during the war. When the war ended, however, McLean, like most Virginians, was virtually penniless. The McLeans still owned hundreds of acres of land in Northern Virginia, but the land was virtually worthless for resale and McLean was heavily in debt. Eventually, the ever-practical McLean turned his attention to politics, joined the Yankee Republican Party, supported Grant in the election of 1872 and was rewarded by an appointment to a U.S. Treasury job.

These are the facts of Wilmer McLean—family man, shrewd merchant and resourceful survivor. But fate was to take a hand in Wilmer McLean's life, making him one of the most unusual characters in American history, for the Civil War virtually began in his kitchen in Manassas and ended in his front parlor at Appomattox Court House. On July 18, 1861, the advancing Union army began probing Confederate defenses along Bull Run Creek at a place called Blackburn's Ford. General Beauregard, the Confederate commander, set up headquarters at Yorkshire to keep a closer eye on the Union army. About noon, an artillery duel started. One of the Union shells smashed into the chimney of the McLean house. Dropping down the chimney, the shell exploded in a big iron kettle simmering on the fire, plastering the kitchen with stew meant for dinner. Miraculously, no one was injured. As earlier noted, in March 1862 McLean and his family moved to central Virginia, where they were immune from the sights and sounds of war for three years. On the morning of April 9, 1865, however,

Strange But True?

The Wilmer McLean house at Appomattox Court House. *Courtesy of the Library of Congress.*

two horsemen, one Federal and one Confederate, ordered McLean to conduct them to some house with a large room where a conference could be held. After taking them to several other houses, McLean finally brought them to his own house. The two officers chose McLean's house for the historic meeting between Generals Lee and Grant in which General Lee surrendered the Army of Northern Virginia. Over the next few days, souvenir hunters from the Union army virtually gutted the parlor in the rush for mementos of the historic occasion.

UNIDENTIFIED FLYING OBJECTS

On March 23, 2005, during a thunderstorm, a Clifton woman observed something very strange, very strange indeed. The woman's husband reported:

We had a power outage last night and my wife was awakened by the answering machine clicking on and off as the power tried to recover, and

119

then it went out completely. She went to the front door to see if it was raining or windy and saw a very large object hovering over a nearby house about one-eighth of a mile from our house. It was larger than the house, seemed to be at an angle to her view with the bottom exposed and had lights all around it evenly spaced. When it began to move away, several lightning flashes were seen and then it was gone. The power returned two hours later

The appearance lasted just a few seconds, from the "balls of light" formation to the vertical lightning flash. The woman may have witnessed a natural rare atmospheric phenomenon involving multiple ball lightning. Alternatively, she may have seen a UFO.

Northern Virginia is no stranger to UFO sightings, but the best-documented and most controversial sightings occurred in 1952 during the so-called Washington Flap. From July 19 to July 29, 1952, a series of UFO sightings over Northern Virginia and the city of Washington electrified the country and prompted President Harry S. Truman to call the air force for explanations. At 11:40 p.m. on Saturday, July 19, 1952, an air traffic controller at Washington National Airport spotted seven objects on radar. No known aircraft were in the area, and the objects were not following any established flight paths. This was highly irregular. The equipment was checked and found to be in perfect order. When the obejcts moved into prohibited air space over the White House and U.S. Capitol, the air traffic controller called Andrews Air Force Base.

The air traffic controllers at Andrews reported that they had no unusual objects on their radar screens, but an airman soon called the base's control tower to report the sighting of a strange object. Airman William Brady saw an "object which appeared to be like an orange ball of fire, trailing a tail…[It was] unlike anything I had ever seen before." At 12:30 a.m. on July 20, another person in the airport control tower reported seeing "an orange disk at about 3,000 feet altitude." At 3:00 a.m., shortly before two jet fighters from Newcastle Air Force Base in Delaware arrived over Washington, all of the objects vanished from the radar at Washington National Airport. However, when the jets ran low on fuel and left, the objects returned.

There were also witnesses. Joseph Gigandet of Alexandria, sitting on the front porch of his home, claimed to have seen "a red cigar-shaped object," which sailed slowly over his house just prior to the radar sightings at Washington National Airport.

Strange But True?

On July 22, the *Washington Post* broke the story:

> *The Air Force disclosed last night it has received reports of an eerie visitation by unidentified aerial objects—perhaps a new type of "flying saucer"—over the vicinity of the Nation's Capital. For the first time, so far as known, the objects were picked up by radar—indicating actual substance rather than mere light.*

The article went on to report:

> *The airport traffic control center said* [a] *Capital-National Airlines Flight 610, reported observing a light following it from Herndon, Va. about 20 airline miles from Washington, to within four miles of National Airport.*

On July 28, 1952, the headline of the *Alexandria Gazette* read, "Jet Fighters Outdistanced by 'Flying Saucers' Over Mt. Vernon and Potomac." The article went on to explain:

> *Jet fighters of the Eastern Interceptor Command today were maintaining a 24-hour alert for "flying saucers" over the Alexandria vicinity. The order was issued after radar operators at the CAA Air Route Traffic Control Center at National Airport sighted the mysterious objects Saturday night—the second time in eight days. The Air Force said two jets pursued "between four and twelve" of the elusive objects Saturday night, but the pilots reported they were unable to get any closer than seven miles before the saucers disappeared. One pilot said he saw "a steady white light" about ten miles east of Mt. Vernon. His supersonic jet, traveling at a speed of more then 600 miles per hour, was outdistanced when he sought to overtake the object.*

The sightings of July 26 and 27 made headlines across the country and must have unnerved President Truman, who personally called the air force's UFO expert, Captain Ruppelt, and asked for an explanation of the sightings. Ruppelt told the president that the sightings might have been caused by temperature inversion, in which a layer of warm, moist air covers a layer of cool, dry air closer to the ground. This condition can cause radar signals to bend and give false returns.

On July 29, 1952, the *Alexandria Gazette* reported, "Saucers Seen Again Early This Morning: Flying saucers circled the Northern Virginia area again this morning." The article went on to explain:

The CAA says its radar picked up the saucers about six straight hours early today as they circled between Herndon, and Andrews Field…Saucer experts from Wright Field, Ohio have been called to Washington for a special conference on the phenomenon. The group was scheduled to arrive last night, but was delayed by plane trouble and will instead meet today.

On July 29, 1952, in the largest press conference held at the Pentagon since the conclusion of World War II, the air force declared the visual sightings over Washington misidentified aerial phenomena. The air force also stated that the radar-visual reports could be explained by temperature inversion. Neither Captain Ruppelt, who left the air force, nor any of the radar and control tower personnel at Washington National Airport agreed with the air force explanation.

URBAN LEGENDS

On May 12, 1979, the front page of the *Washington Post* carried an article titled "The Mount Vernon Monster." For nine months, in 1978 and 1979, a strange creature wailed and screamed nightly in the woods just a mile from historic Mount Vernon. Some people called it the "Mount Vernon Monster"; others, "Bigfoot." Whatever the creature may have been, it was elusive, frustrating capture attempts by the police, flyovers by a U.S. Park Service police helicopter, searches by volunteer youth patrols and the determined efforts of the Fairfax County game warden to track it down. And thus an urban legend was born.

Witnesses began to appear, happy to tell their tales to every passerby. One witness reported:

Just as I got to the edge of the woods, it screamed a second time. And I could feel the reverberations. I could feel it in my chest, like if you stand in front of a bass speaker, I could feel it in my chest, and it made every hair on the back of my neck stand up. And I could hear twigs break and branches snapping.

Years later, accounts are still circulating:

I was one of those teenagers in the late '70s who heard the Mt. Vernon monster. I actually had a tape recording of it but my little sister taped

over it. Yes, down an unpaved road leading to Union Farm we parked our cars late at night and quietly waited. Dogs would start barking nearby and sure enough we then heard the howl of the Mt. Vernon Monster. I also have a friend who saw the creature not far from the back gate of Mt. Vernon, off Old Mt. Vernon Road near the Potomac River, one snowy day. She was nearly two hundred yards away and at first glance thought it was a man walking toward the woods. She quickly realized it was not. She described it as large and hairy.

The story made its way into oral history projects, which are now being cited by monster hunters as historical authentication of the creature's existence:

One of the game wardens said, "The thing seems to know when you leave the woods, then it starts to holler." One resident said she spotted the monster. She described it as a creature about six feet tall, which lumbered into the woods after being sighted.

The howling stopped as abruptly as it began, but the story lives on.

Another, far grislier urban legend relates to a homicidal maniac dressed in a bunny costume. According to this urban legend, "bunny man" murdered teenage couples at night and took their bodies to a railroad bridge near Fairfax Station, christened by local teenagers as "Bunny Man Bridge." The body count rises with each retelling of the story, having now reached thirty-two. In 2001, the Fox Family Channel ran a segment on the program *Scariest Places on Earth* called "Terror on Bunnyman's Bridge."

Do these stories have any basis in fact? Was the bunny man real? Brian A. Conley, historian-archivist with the Fairfax County Public Library, undertook the task of tracking down the real bunny man. Conley discovered the origins of the legend in a *Washington Post* article of October 22, 1970: "Man in Bunny Suit Sought in Fairfax." According to the article, the real bunny man accosted a young couple on Guinea Road.

Air Force Academy Cadet Robert Bennett told police that shortly after midnight last Sunday he and his fiancée were sitting in a car in the 5400 block of Guinea Road when a man "dressed in a white suit with long bunny ears" ran from the nearby bushes and shouted: "You're on private property and I have your tag number."

The man then threw a hatchet through the right front car window. No one was injured, and the man ran off into the woods. On October 31, the newspaper reported that the bunny man had reappeared:

> *A man wearing a furry rabbit suit with two long ears appeared—again—on Guinea Road in Fairfax County Thursday night, police reported, this time wielding an ax and chopping away at a roof support on a new house.*

Confronted by a patrolling security guard, the bunny man made his escape, but not before threatening the security guard. Conley ferreted out the official police report, which read, "At 10:30 p.m. on October 29, 1970, six officers responded to 5307 Guinea Road for 'a subject dressed as a rabbit with an ax.'" Bunny man made one more documented appearance, accusing Kings Park West residents of dumping trash.

The ability of people to manufacture alternative "truth" in the face of documented facts appears unlimited. The following are some of the latest iterations of the bunny man legend:

1.) A young man from Clifton, Virginia, came upon Bunny Man Bridge and later killed his parents. He dragged their bodies into the woods to hang them from the bridge and then killed himself.

2.) In the 1940s, three teenagers were at the Bunny Man Bridge on Halloween night. The three youths were found dead, hanged from the bridge. Police discovered a note that read, "You'll never catch the Bunny Man!"

3.) In 2001, six local students found mutilated bunny parts during a search of the area and left the forest after they heard noises and saw figures moving around in the woods.

Selected Bibliography

Books

Brownlee, Richard. *Gray Ghosts of the Confederacy.* Baton Rouge: Louisiana State University Press, 1975.

Flynn, Kevin, and Elisabeth Wooster. *The Potomac River Guide.* Kensington, MD: Flynn and Wooster Editorial Services, 1995.

Geddes, Jean. *Fairfax County Historical Highlights from 1607.* Middleburg, VA: Denlinger, 1967.

High, Mike. *The C&O Canal Companion.* Baltimore: Johns Hopkins Press, 2001.

Marinucci, Kathy W., ed. *Fairfax County Stories 1607–2007.* Fairfax, VA: Fairfax County Board of Supervisors, 2007.

Meany, Marion, and Mary Lipsey. *Braddock's True Gold.* Fairfax, VA: Fairfax County Board of Supervisors, 2006.

Mills, Charles A. *Echoes of Manassas.* Manassas, VA: The Manassas Museum, 1988.

Munson, James D. *Col. John Carlyle, Gent.* Alexandria: Northern Virginia Park Authority, 1986.

Netherton, Ross, and Nan Netherton. *Fairfax County in Virginia: A Pictorial History.* Norfolk, VA: The Donning Press, 1986.

O'Neill, Patrick L. *Mount Vernon.* Charleston, SC: Arcadia Publishing, 2003.

Peters, James E. *Arlington National Cemetery: Shrine to America's Heroes.* Bethesda, MD: Woodbine House, 2000.

Selby, John E. *The Revolution in Virginia 1775–1783*. Williamsburg, VA: The Colonial Williamsburg Foundation, 1988.

Virginia Writers Project. *Prince William: The Story of Its People and Its Places.* Washington, D.C.: Works Progress Administration, Government Printing Office, 1941.

Whitt, Jane Chapman. *Elephants and Quaker Guns*. New York: Vantage Press, 1966.

Wills, Mary Alice. *The Confederate Blockade of Washington, D.C., 1861–1862*. Shippensburg, PA: White Mane Publishing, 1998.

Websites

Adams, T.H. "Washington's Runaway Slave." President's House in Philadelphia. http://www.ushistory.org/presidentshouse/index.htm (accessed September 29, 2009).

Alexandria Archaeology Museum. "Freedmen's Cemetery." City of Alexandria. http://alexandriava.gov (accessed September 29, 2009).

Alexandria Black History Museum. "America's First Sit Down Strike: The 1939 Alexandria Library Sit In." http://oha.alexandriava.gov/bhrc/lessons/bh-lesson2.html#introduction (accessed September 29, 2009).

Beers, Peter. "The Luis Marden House:1952." http://www.peterbeers.net/interests/flw_rt/Virginia/Marden/index.htm (accessed September 29, 2009).

Cavileer, Sharon. "Growing Success at Ivakota Farm—Troubled Young Women Get a Helping Hand to Gain a Leg Up." *Fairfax Chronicle.* http://www.chroniclenewspapers.com/archives (accessed September 29, 2009).

Chapman, Lindsey. "On This Day: Dust Storm Devastates Great Plains, Fills Skies of Chicago and NY With Soil," May 11, 2009. Finding Dulcinea Librarian of the Internet. http://www.findingdulcinea.com (accessed September 29, 2009).

Crookshanks, Barbara. "Alum Spring Park: A Walk Through History." Historypoint.org, Central Rappahannock Regional Library. http://www.historypoint.org (accessed September 29, 2009).

Crothers, A. Glenn. "Quaker Merchants and Slavery in Early National Alexandria, Virginia." *Journal of the Early Republic* 25, no. 1 (2005): 47–77.

Project Muse, Johns Hopkins University. http://muse.jhu.edu (accessed September 29, 2009).

Dotson, Rand. "Progressive Movement in Virginia." *Encyclopedia Virginia*, Virginia Foundation for the Humanities. http://www.encyclopediavirginia. org (accessed September 29, 2009).

Dvorak, Petula. "Fort Hunt's Quiet Men Break Silence on WWII." *Washington Post.* http://www.washingtonpost.com (accessed September 29, 2009).

Gerson, Evelyn. "Ona Judge Staines: Escape from Washington." SeacoastNH. com. http://www.seacoastnh.com (accessed September 29, 2009).

Kelly, James. "Becoming Americans Again." Virginia Historical Society. http://www.vahistorical.org/index.htm (accessed September 29, 2009).

Lepore, Jill. "Goodbye, Columbus." *New Yorker*, May 8, 2006. http://www. newyorker.com (accessed September 29, 2009).

Mitchell, Patricia. "Colonial Food in Colonial Williamsburg." Food Notes. http://www.foodhistory.com/foodnotes/index.htm (accessed September 29, 2009).

PBS Frontline. "George & Venus." PBS. http://www.pbs.org (accessed September 29, 2009).

Pompeian, Ed. "George Washington's Slave Child?" History News Network, George Mason University, March 21, 2005. http://hnn.us (accessed September 29, 2009).

Raynor, Patricia. "Off the Wall: New Deal Post Office Murals." Smithsonian: National Postal Museum. http://www.postalmuseum.si.edu (accessed September 29, 2009).

Watson, Barbara, and Bill Sammler. "Winter Weather History." Virginia Department of Emergency Management. http://www.vaemergency.com (accessed September 29, 2009).

About the Author

C huck Mills has a passion for history. He has roamed the world researching historical topics and is delighted to have lived most of his life in Northern Virginia, one of the most historic regions in the country. He now lives on the banks of the Potomac River, on land once owned by George Washington.

Chuck is a graduate of Penn State University and has advanced degrees from Penn State and George Washington University. He recently completed a master's degree in American history at George Mason University in Fairfax, Virginia.

Chuck is a member of the Alexandria Historical Society, a former member of the Board of Directors of the Manassas Museum and has acted as a docent at the Carlyle House Historic Park in Alexandria. He is the author of numerous books, including *Alexandria 1861–1865*, *Echoes of Manassas* and *Treasure Legends of the Civil War*. Chuck has also written numerous newspaper and magazine articles on historical subjects. He is the producer and co-host of *Virginia Time Travel*, a history television show that airs to some two million viewers in Northern Virginia.

When not writing or doing historical research, Chuck can be found kayaking on the Potomac River.